COLOR
PRINTING

COLOR PRINTING

MATERIALS, PROCESSES, COLOR CONTROL

David A. Engdahl
School of Photography
Rochester Institute of Technology
Rochester, New York

FOURTH EDITION

AMPHOTO
American Photographic Book Publishing Co., Inc.
Garden City, New York 11530

With Appreciation

*I would like to thank Professors Ira Current and
A. Ronald Handy for their help in putting together
the material in this new edition.*

LIBRARY OF CONGRESS CATALOG CARD NO. 62-12681
ISBN 0-8174-2420-2

Manufactured in the United States of America.

CONTENTS

INTRODUCTION

Since the beginning of time, man has viewed his surroundings in full color, but it has not been until recently that the amateur photographer has been able to make color prints in his own darkroom. Now, with an ordinary enlarger used for black-and-white printing, a few materials peculiar to the color process, and a little extra care, he can produce color prints equal to the best of them.

How does the advanced amateur make a good color print? By learning about the process he is working with and using careful procedures all along the line. Color processes available today need not hamper the amateur from using the color material he is most familiar with. If one likes to use reversal materials such as Ektachrome, GAF, or Kodachrome, there are suitable materials for making color prints from these transparencies. If you have become familiar with the color negative materials such as Kodacolor or Vericolor, these can be used to produce both transparencies and color prints.

The advanced amateur, in working with color materials, learns that color materials are more fragile than black-and-white materials and that he must take more care in eliminating dust from both his camera and printing systems. If he does processing in his own darkroom, then he must take more care in the timing and in the temperature control of the color process. It is always a great experience and thrill to view a black-and-white print when it starts to come up in the developer, but it is even more so when you see the print appear in full color, the way you saw the subject with your own eyes.

Many topics are covered in this book, beginning with the production of the color negative, through the printing of the color negative, and also the printing of color transparencies. One need not have expensive equipment in order to work with color materials, although certain pieces of equipment are essential. The average darkroom is equipped to handle most problems encountered. The exposing and processing of color reversal camera materials are not covered in this text, as they are adequately covered in other places. The color negative is discussed with regard to its characteristics, exposure, and processing. Some of

the topics we must cover under the exposure of color film are the type and size of color negative films available in the United States; the film speeds of the materials; how to judge when you have properly exposed your films; some of the foreign films available in the United States; and treatment of color film before, during, and after exposure.

The techniques for working with Ektacolor 37 RC Paper, Ektachrome RC Paper, Cibachrome, and Agfacolor Paper are also discussed. The method of working with color paper, per se, is covered in Chapter 4 on Ektacolor 37 RC Paper. These techniques may be adapted to any of the printing processes with adjustments to cover peculiarities of the process you are working with. Therefore, you should be quite familiar with the chapter on Ektacolor 37 RC Paper printing.

As you work with any process and become familiar with the procedures used in color printing, you will find them to come almost as second nature. You should work carefully and try to get the best out of your color materials. You can't just dive in and make color prints without studying how to do it, nor can you expect to know how to do color printing without practical experience. The best worker will read and study about his chosen color process and then try to adapt his knowledge to his darkroom work.

I wish to state that the inclusion of any one color process in this volume does not mean endorsement of the process; this is not the purpose of the book. The processes included all have their place in the photographic world. Each process may have its advantages and disadvantages, but each is capable of producing satisfactory prints for the competent worker.

The glossary was added to this volume to help the uninformed understand some of the words and terminology used in the text.

1

EQUIPMENT FOR COLOR WORK

CHECKING THE DARKROOM FOR LIGHT LEAKS

The average darkroom will do very nicely for the exposing and processing of color materials provided that it is completely lighttight. You should have no light leaking into the room. If you have a makeshift darkroom, it is better to be sure that it is safe for color materials than to be sorry when you have expended a lot of time and money.

One way to check your room for leaks is to turn off all the lights on entering. After sitting in the darkness for five minutes or so, turn your head around in all directions and look for small shafts of light. Do this inspection during the daytime or have the lights on outside the darkroom so you have the greatest opportunity to spot any leaks. Move around the room looking near the ceiling and also near the floor for leaks.

Another way you can check for leaks in your darkroom is to enter the room, turn off all the lights, and then place small strips of a fast panchromatic film in various places in the room—on the floor, on chairs, on the work bench, in the sink. After waiting twenty minutes, develop these with an unexposed strip of film, fix, and rinse. Examine the exposed strips for fog density, comparing them with the unexposed film. If there is no difference, then the room is safe. If one or more strips show a fog, then you need to locate and seal off the leak.

PROCESSING EQUIPMENT

Sinks

The type of sink you need depends upon the extent of the color work you intend to do. You need a supply of water, preferably cold *and* hot water. A

9

laundry tub will do nicely for minimum requirements; however, a wash basin type of sink is poorly suited, for it is too shallow and generally too small.

One of the handicaps of working with present-day color materials is that they require development at a specific temperature for a given time. The easiest way to maintain a certain temperature is through the use of a water bath. By this I mean a container large enough to hold either the trays or the tanks in which you are working. The developers are the most critical with respect to temperature, and for the minimum control you probably can get along with only babying the developer or developers, depending on the process.

A type of work-area sink that is slightly removed from the water supply can easily be made by anyone handy with tools. It is simply a shallow box made of plywood or other available boards and coated on the inside with Fibreglas and resin. Not having running water in this type of sink presents a slight problem, because you then have to transport the water back and forth, but color work can be done in this manner. You need to have a large tray, which will be the water bath for the developer tray. Any water or solutions spilled in the Fibreglas sink are easily cleaned up.

If you wish to get really fancy, there are many types and sizes of stainless steel sinks on the market. If you are able to afford such an item, make sure you look closely enough at your needs so that you don't get too small a sink. If you anticipate developing 16″ × 20″ prints, then you must plan your equipment accordingly. In purchasing a stainless steel sink, specify type 316 stainless steel. This is the best all-around one for most photographic work. Don't expect stainless steel not to rust. If you mistreat it by leaving bleaches in contact with it for any long periods of time or allow iron to come in contact with the stainless steel, then you may expect trouble. Most stainless steel equipment manufacturers carefully instruct you in the care of their equipment—follow these instructions carefully. One point of great importance: *never clean stainless steel with steel wool.*

If you have a large sink, stainless steel or otherwise, a useful item to have is a standpipe. This is a short piece of pipe or tubing that fits into the drain of your sink, allowing the water to rise and stay at a certain level. The height of the standpipe determines the level of the water, which now acts as a water bath. The depth naturally depends on the size of the tanks or trays you are going to use. You may want different lengths of standpipe for different processing conditions. The water should come up about half way on the trays and higher on the tanks. You have to watch out for the trays getting into water too deep and then floating away, spilling, or flooding the solutions contained therein. However, you can only tell how it is going to work out for you by trying.

Water

Water plays a most important part in the processing. You mix the solutions with it, and you must cool or warm the solutions and wash the film or paper with it.

Very soft water will likely give you trouble in processing; likewise, very hard water may pose certain problems when you mix your solutions. Slightly hard to hard water seems to work best of all.

The water you use should be free from grit, for nothing ruins a film faster than washing it in dirty water. It is possible to filter out dirt particles with the use of a filter built into the water line.

A useful item in your sink is a water mixer. This may be as simple as two hoses (one hot and one cold) or as complex as an automatic mixer. In any event, you should be able to adjust the temperature of the mixture of hot and cold water to that of the color process you are using. If it should happen that the cold water is not cold enough, as it might be during the summer, then you will need other measures to cool your solutions. Ice water is the simplest means of cooling the water bath. You have to be careful that the developer is not too cold or some of the chemicals in it might precipitate out, and the solution will be ruined. A more expensive means for cooling the cold water is an electric refrigeration cooling unit.

Today, more and more color processes have elevated temperature requirements in the vicinity of 85 or 100 F. Now the problem sometimes becomes one of not having enough hot water to keep the wash water at the proper temperature.

Thermometers

Color processing requires the use of a fairly reliable thermometer. The thermometer should fulfill several requirements: (1) its graduations must be easy to read, (2) it should react fairly rapidly, and (3) it should have a small range, yet large enough to accommodate most photographic processing. This range might run from 65 to 125 F.

Thermometers may serve another purpose other than temperature measurement. Some are encased in steel jackets, and in this shape (long, thin), they can be used as stirring rods. One warning: thermometers doubling as stirring rods are easily broken. Use your thermometer carefully; don't bang the sides or bottom of the tank or graduate with it.

Many thermometers are now being manufactured indicating both the Fahrenheit scale and the Centigrade (Celsius) scale. The United States will be gradually switching from Fahrenheit to Centigrade. You should be able to adapt to using either scale for processing.

Hangers for Processing Sheet Film

There are many types of film hangers available for processing sheet film. Two are shown in fig. 1-1. These happen to handle 4″ × 5″ sizes of sheet film and are made of stainless steel. Any hanger you purchase should (1) be able to be easily loaded in the dark and (2) secure the film after loading so that it will not come out during any agitation in processing.

The single hanger handles one sheet of 4″ × 5″ film and is perfectly

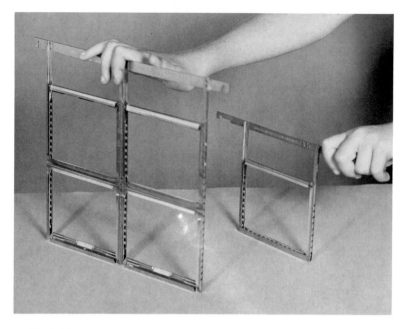

Fig. 1-1. Two types of hangers for processing sheet film, a single 4″ × 5″ hanger, and a multiple 4″ × 5″ hanger.

satisfactory for someone processing in small quantities. It fits most ½-gallon size tanks and some 1-gallon sizes. For quantity processing, the second type of hanger is preferred, for it holds four sheets of 4″ × 5″ film. This hanger is referred to as a multiple hanger. It must be used with a deep tank (the smallest available is a 1-gallon size).

Hangers for Processing Color Paper

There are three methods of processing color paper that can be carried out in the ordinary darkroom. These are (1) using hangers in small tanks, (2) processing the paper in trays, just as you would process black-and-white paper, and (3) using a drum or similar processor.

To do a better job of processing using ordinary film hangers, treat the hangers in a special way. When non-resin-coated paper becomes wet, it becomes very soft and pliable—it also stretches or expands. This is no problem when you process paper in trays. In fact, you really never realize it is happening, but this softening causes the paper to billow out of the hangers, with the result that the emulsions get scratched, or the paper comes out of the hanger and is lost in the bottom of the processing tank. To prevent loss of or damage to the pictures being processed, a device is needed to hold the paper in the film hanger. One thing you might do is adapt the hanger for processing color paper. First remove the top support bar, as in fig. 1-2. Next take some plastic window screening, such as you will find in hardware and department stores, and cut a

piece a little larger than twice the size of the hanger. Cut the screening in such a way that the finished edge of the screening will be along the top of the hanger (fig. 1-2).

In a sense, you are wrapping the hanger in the screening. With the screening around the hanger, the bottom and one edge of the hanger will be adjacent to the cut, raw edges of the screen. These cut edges must be glued to each other while on the hanger. The width of the screening should be such that an 8″ × 10″ piece of paper will just come to the edge of it when the paper is inside the hanger. Overlap the edges of the screening on the side and bottom of the hanger. You must get the screening as tight as possible. This can be done by pulling the screening tight and clamping it with a clothespin while you cement the edges. Various cements may be used to fasten the screen in place, but the one I have had success with is DuPont Duco cement. Apply it along the cut edges of the screening and let it dry thoroughly. Work with the cement so that you obtain a fairly smooth joint. Be careful not to put it on so generously that the cement runs into the inside of the hanger and blocks the channel. If cement does get into the channel, clean it out before it dries. Hangers such as these can be used for processing two sheets of 8″ × 10″ color paper back to back.

Tanks for Processing Roll Film

Processing tanks come in a variety of sizes and are made of different types of material. The kind you buy depends upon the use you have for the tank.

Fig. 1-2. At the left an 8″ × 10″ hanger; in the middle an 8″ × 10″ hanger with upper bar removed; at right an 8″ × 10″ hanger with its plastic screen covering.

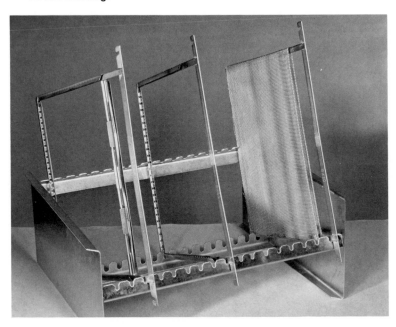

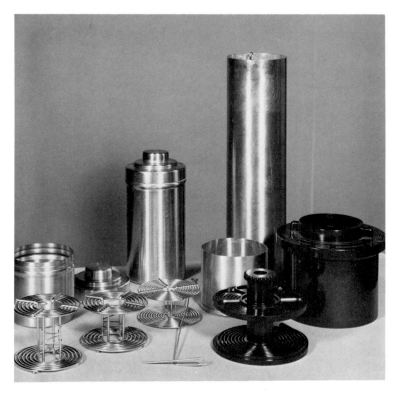

Fig. 1-3. Reels and tanks for processing roll film. Tanks in background hold more than one reel.

Tanks for processing roll film may be made from stainless steel or from any of the popular modern plastics. There are several points you should look for in purchasing a tank. One is does it fulfill the size requirements for your particular camera or cameras? This means that if you have more than one size camera, you will need more than one size reel to go into the processing tank.

Some tanks are available with adjustable reels so that you can process 35mm one time and 120 another. Fig. 1-3 shows a series of different size reels and two types of tanks. If you shoot a lot of color film, you should have a tank that accommodates more than one reel at a time, and not only more than one reel, but more than one size reel. One of the main points in color processing is the requirement of close temperature control. This means that you try to maintain the temperature in the tank to a very close tolerance. Some processes state plus or minus (±) ½ F. If you have a tank composed of an insulating material, as a plastic is, it is difficult to change the temperature within the tank; whereas, if you have a stainless steel tank, it is relatively easy to change the temperature. This property of stainless steel can work to your disadvantage. If your water bath or method of maintaining the interior temperature fluctuates, then the temperature within the tank will also vary. Plastics, however, do hold a given temperature better than stainless steel.

Another point about roll-film tanks that might be considered is the question whether the film can be easily loaded. Color film has to be loaded in complete darkness, and therefore you shouldn't have to sweat out a lifetime in the dark trying to get a roll of film onto the reel.

Tanks for Processing Sheet Film

Tanks can be found in sizes for processing sheet film from the 4″ × 5″ size up to and including sizes bigger than 8″ × 10″. However, since most amateurs do not work with materials larger than 8″ × 10″, I will restrict my discussions to equipment for processing up to the 8″ × 10″ size. Again, these tanks are available in stainless steel, rubber, and various plastics. The capacity of the tank is also an important consideration. If you intend to do a lot of sheet-film processing, then you will need a larger size tank. Tanks for handling 8″ × 10″ material, and also multiple 4″ × 5″ hangers, are available from 1-gallon size up to 3½-gallon size. A variety of these tanks is shown in fig. 1-4. In fig. 5-1 there is a larger tank used as a water jacket in which smaller, in this case stainless steel, tanks are inserted. The water jacket is held to a given processing temperature to maintain the temperature of the processing solutions. If you buy stainless steel tanks, it is desirable to get type 316 stainless steel. Do not store your color processing solutions in the stainless steel tanks, but rather pour them back into storage bottles.

Fig. 1-4. Processing tanks. Left, 1-gallon 8″ × 10″ stainless steel tank; top middle, ½-gallon 4″ × 5″ stainless steel tank; bottom middle, 1-gallon 4″ × 5″ stainless steel tank; right, 1-gallon 5″ × 7″ hard rubber tank.

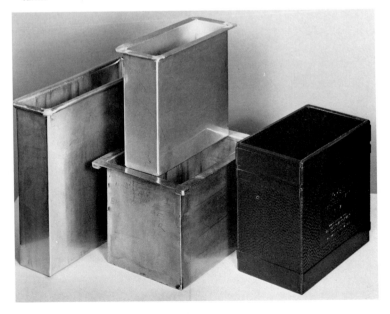

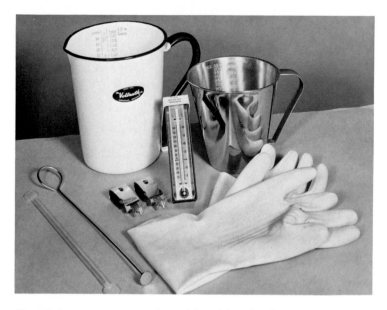

Fig. 1-5. Some necessary equipment for mixing chemicals and processing: graduates, mixing or stirring rods, film clips, thermometer, and rubber gloves.

The construction of the tank, particularly of the rectangular ones, is important also. Any seams that are within the tank should not be soldered—they should be either folded or welded. If you first outline your processing needs and then look over the equipment available, you are more likely to make a better selection than if you rush out to the corner photo store and purchase any processing tank available.

Clips

For drying your roll film or sheet film, it is handy to have either clothespins or some type of plastic or stainless steel clips. When picking a clip, make sure that it will grab the film securely. Some plastic clips, even though they do clamp onto the film, allow wet film to slide right out, subjecting it to possible damage. Stainless steel clips of the pressure type have little teeth to clamp onto the film and hold it securely. It is generally a good idea to have enough clips so that you can clip onto both ends of a roll. Sheet film really needs only one clip to suspend it from a line. Allow enough room so the films won't touch, especially with sheet films, because they curl as they dry.

Trays

Color paper is most easily processed in tanks or in a drum, but it isn't absolutely necessary that you use a tank or drum. Very satisfactory results can be obtained by processing in ordinary trays. These may be made of a variety of materials—stainless steel, plastic, hard rubber, or Fibreglas. You should have a tray that is a little larger than the size paper that you intend to process in it. Probably as few as five trays or even four will do in most color paper processes. You should have enough trays to carry out the dark stages of the processing without having to change solutions in any one tray.

Even if you use trays, try to maintain some type of temperature control, probably by using a water bath in a sink, or in a double tray where the smaller tray is set in a larger tray and water surrounds the smaller tray. In any event, you should carefully analyze your needs so you get the equipment that will fit in your darkroom, fit your budget, and also do the kind of job that you want.

Gloves

It is wise to take precautions in color processing and color mixing, since you don't know what chemical ingredients might be in a solution and, therefore, might be toxic or irritating to your skin. The easiest way is to use rubber gloves, such as Playtex gloves (fig. 1-5). Any rubber glove can be used, but ones that are easily slipped on and off seem to work best. Unfortunately, when using rubber gloves, most people find that their sense of touch is somewhat curtailed, but with practice, you can become very adept at handling paper either in a tray or in a hanger. Keep your gloves clean, rinsing them thoroughly after being in any processing solution.

Since we generally try to produce the highest quality print we can with a given process, we try to avoid scratches and fingerprints. Some of us have no problem handling film—we don't leave fingerprints on photographic material no matter how we handle it. There are, however, a few of us who leave a nice, fat, greasy fingerprint if we just touch a material. In such a case, the way to avoid fingerprints is to handle the sensitive material wearing thin white cotton gloves. These are relatively inexpensive and can be laundered if they get soiled.

Graduates

Each darkroom should have one or two graduates for measuring and also possibly for mixing solutions. The ordinary glass or plastic graduates work fine, but you might use a type such as the one shown in fig. 1-5. Here you have an enameled graduate and a stainless steel graduate. You must be careful you do not chip the enameled graduate; otherwise each works equally well.

Mixing and Storage Equipment

You need some equipment in your darkroom to help you mix the process-
ing solutions. Depending upon the size of the processing kit you use—whether
it be a 16-ounce kit or a gallon kit, or larger—you should anticipate your needs
by providing receptacles large enough to mix the solutions in. A plastic or
stainless steel pail is most handy if you are going to mix a large-size processing
kit; but if you are only going to mix a small-size one, then glass graduates or
enameled graduates are all that are needed. As with other items, there are
numerous pails, graduates, and measures made in a variety of materials, costing
from a few cents up to many dollars per item. Enamelware is perfectly satisfac-
tory for mixing color solutions, provided there are no cracks or rust spots.
These areas cause contamination when mixing the solutions and could very
likely ruin any solution you mix.

One of the main things you should have is a graduate or measure that
measures accurately—whether it be 16 ounces, a quart, or a gallon. The con-
tainer that you mix the solutions in should be larger than the total volume of the
chemicals. It should be easy to clean, and it shouldn't be too fragile. Funnels
are a convenience when pouring your solutions into storage bottles—use one
with at least a 4-inch diameter. Some solutions may be mixed just prior to use,
while others have to stand for several hours before they can be used. In most
cases, you will probably need some type of storage container. Plastic or glass
bottles of the same size as the volume of solution that you are mixing are the

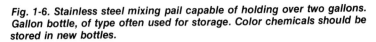

*Fig. 1-6. Stainless steel mixing pail capable of holding over two gallons.
Gallon bottle, of type often used for storage. Color chemicals should be
stored in new bottles.*

Fig. 1-7. Interval timer for processing operation.

most convenient storage containers you can buy. Don't buy gallon containers for storing a quart or pint of solution; use quart containers for quart quantities. It is also preferable to have plastic caps and not metal caps, which rust or react with the solution. The bottles should be clean before you put any solution into them. If after repeated use bottles show stains or scum on them, then they should be discarded and new containers used. Label all bottles carefully so that there is no mistake as to the contents. The label should state the type of solution and also the date of mixing. If these solutions are used repeatedly for processing, a record should also be kept of how much material has been run through them.

Processing Timers

Since a good many steps of most color processes are carried out in total darkness, you need some means of timing them accurately. This can be done by

using several interval timers, setting one for the developing time, another for stop bath, and so on, or by using one timer that has a luminous dial and hands so you can easily see the clock at any step of the process. A good interval timer is the GE model (fig. 1-7) or similar make. One with a luminous dial is the Gra Lab timer (fig. 1-8). You could even take a kitchen clock with relatively large hands and then paint the hands with a luminous paint so they can be seen in the dark.

Fig. 1-8. Timer useful both for processing and exposing operations. Dial is luminous for easy seeing in the dark.

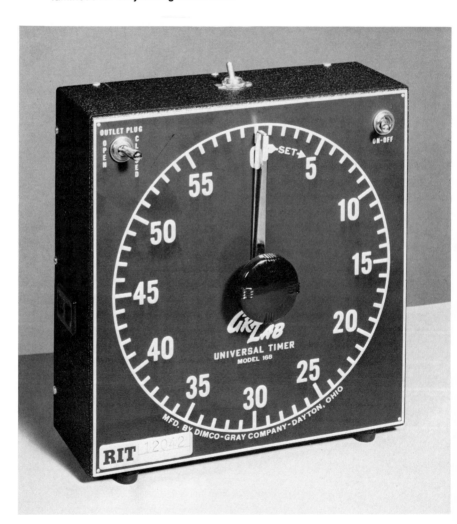

DRYING EQUIPMENT

The drying procedure is really quite fussy when it comes to color film, because here you can ruin your efforts very easily. If you pick up dust or dirt from the air onto the film, you have made a permanent impression on the soft film emulsion that is very difficult to remove. In most cases, the dirt causes extra work in spotting later on. This work can be avoided at the beginning by taking care during drying. The simplest type of equipment for drying is just a line with film clips hanging from it. This should be in a room that is relatively *free of dust.*

If you want something that is fancier, some manufacturers of processing equipment do make drying cabinets for a few dollars up to many hundreds of dollars. Some drying equipment operates on the heated-air principle, some on the dehydrating principle—by this I mean that a chemical is used through which the air is circulated. This chemical removes any moisture in the air, and the air is used over and over again. The dry air then picks up any moisture from the film. A drying cabinet can be constructed from any box big enough to contain your hanging film. In such a box, you have to have some kind of arrangement for circulating and replacing stale air with fresh. If you hang wet film in a small, closed area it will not dry, for the moisture just saturates the air, which is then unable to remove more moisture from the film. To enable drying to take place, the air must be de-moisturized. A small fan and air vents will do the trick.

Equipment for drying color paper is really simpler than that used for drying the film. Most color papers air dry best. This means that if you lay the paper face up on a blotter in a relatively dust-free area, the print will dry satisfactorily. You can improve upon this simple method by providing screens, either like window screens or ones you can make out of cheesecloth. By piling the screens on top of each other and using a narrow depth frame, you can restrict the curling of the paper as it dries.

Ferrotyping of color paper is to be avoided unless you know the particular type of color paper you are using can be ferrotyped. Resin-coated (RC) papers are not designed to be ferrotyped. The surface of the paper designates the final finish of the dry print. Glossy RC paper has a high gloss finish when dry.

EXPOSING EQUIPMENT

One of the items that probably has been overlooked in many darkrooms is the power supply—the electricity available for exposing the color paper. This is critical, and if you happen to be in an area where there is an irregular amount of draw on your electric current, you will get erratic results. The remedy for this voltage fluctuation is a voltage regulator (fig. 1-9). These are obtainable in a number of different sizes and produce a constant voltage supply of, say, 115 volts.

You may sometimes have as low as 90 volts or as high as 130 volts being

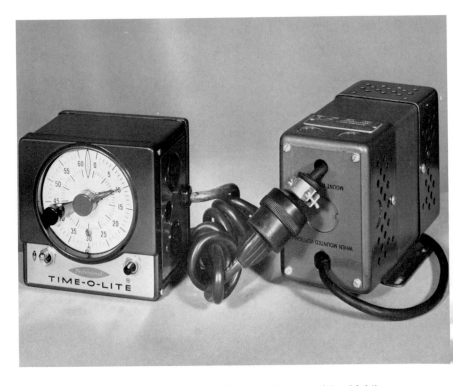

Fig. 1-9. Exposing timer (left) and voltage regulator (right).

provided. The change from 90 to 130 volts without voltage regulation would cause great changes in the exposure on your color material—exposure differences in color balance and density. A voltage regulator is probably one of the most necessary items in a darkroom. The size of the voltage regulator you pick depends upon the size of your enlarger. By "size" is meant the wattage the bulb in your enlarger draws. If it draws 150 watts, then get a 150-watt voltage regulator; if 200 watts, get a 200-watt regulator. Get one that is the same size or slightly larger than what you need. If you have a 75-watt bulb, there is no need to buy a 250-watt voltage regulator unless you plan to get a bigger enlarger. A large voltage regulator does not do as good a job as one that is near the output of the lamp or equipment that you are using.

Enlargers

Enlargers for color printing are available from many different manufacturers. I am most familiar with three enlargers: the Omega, the Beseler, and the Chromega. The first two are condenser enlargers, and models can be obtained that have color heads on them. Color heads are a convenience for the color

printer in that he can put filters in them to change the color balance of his print (fig. 4-2). These are not absolutely necessary, and very fine color prints can be made in enlargers without color heads.

The Chromega is a color enlarger that has color filters built into the optical system so you don't have to introduce separate filters either in a color head or under the lens. Everything is convenient, and you just dial the kind of filters you need for your particular color printing. The Chromega is a diffusion enlarger, and, therefore, the contrast you get from it is less than that of a condenser enlarger. Condenser enlargers produce more contrast; diffusion enlargers have the advantage that they tend to hide minute scratches that might be on the surface of the negative.

Color Filters

Some means is needed to control the color balance of a print. This is done in the darkroom through the use of filters called color-compensating (CC) filters. If you purchase filters with this designation, it means that they are of optical quality and can be used either in front of the lens or, if they are large enough, in the color head of an enlarger. There are also filters called color-printing (CP) filters. These filters can be used only in the color head of an enlarger and should not be used in front of the lens, as they do not have the optical quality needed to give you sharp images should you project through them. Most manufacturers of a given color process also have available the color filters you need for printing the material. Most CC filters are usable with all color processes. If, therefore, you want to try brand X and you are printing brand Y color paper, you do not need to buy brand Y filters. Brand X filters are quite suitable. CC and CP filters are available in various sizes, so you can choose the size to fit your needs.

Most color printing processes allow you to use certain safelights under carefully controlled conditions. If you must use a safelight, be certain you are not exceeding the manufacturer's recommendation. However, if you learn to work without any safelights, you need never fear fogging from that source.

Timers

Since the exposures for color paper run five or more seconds in length, it is possible to use a luminous timer like the one shown in fig. 1-8, but it isn't very practical. You will find it much handier if you have a timer, such as Time-O-Lite exposure timer (fig. 1-9), to control your enlarger. Many such enlarger timers are on the market. The two requirements you should look for in a timer are repeatability and a fairly wide range of exposure times to set. It is not very satisfactory when, under some cases of exposure, you have to give six or seven

short exposure times one after the other. You are introducing complications; it is preferable to have one continuous exposure time rather than a series of shorter ones.

Easels

Most darkrooms have easels and apparatus for holding paper flat during exposure. It can be as simple as using a piece of clear glass to hold the paper flat, or it can be one of the more expensive easels for this purpose (fig. 1-10). Easels come in all sizes, depending on what your needs are. They run from as small as 5″ × 7″ up to 16″ × 20″ and larger. There are easels that can be used to

Fig. 1-10. Enlarger and easel. This easel also has masks available so that more than one exposure can be made on a sheet of 8″ × 10″ paper.

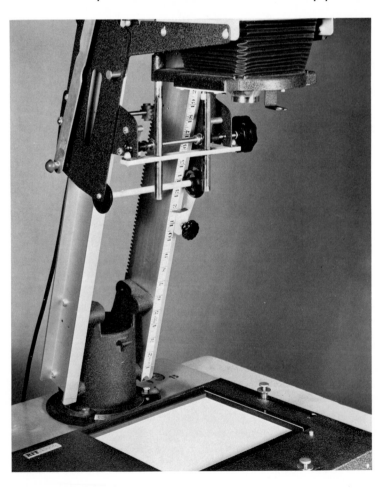

produce more than one print on a sheet. For example, a repeating easel can be used to produce four 4″ × 5″ prints on one 8″ × 10″ sheet. Whatever easel you use, it should be easy to load, it should handle the size print you wish to make, and above all it should hold the paper flat. The Saunders Colorprint Easel is one of those designed for making a series of exposures on a sheet of 8″ × 10″ paper.

Photometers and Other Meters

Not absolutely necessary in a color darkroom, but an item of convenience, is a photometer. This may be an inexpensive Analite meter (fig. 1-11), or it may be as expensive as a footcandle meter. In any case the meter should be able to read low intensities of light. To get really fancy, one could spend several hundred dollars for a photometer, densitometer, or combination. The combination photometer/densitometer instrument can be used to measure the printing qualities of the negative and also, in the darkroom, to set up the enlarger to standard conditions.

A fairly inexpensive visual densitometer (fig. 1-12) is available for the purpose of reading black-and-white and color negatives. The reading you obtain helps you to print a new negative based upon previous experience with a standard negative.

Fig. 1-11. Analite photometer–sensing area is small rectangle at white end of meter.

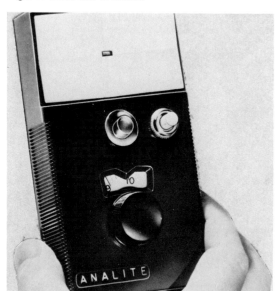

Fig. 1-12. A visual densitometer made by Eastman Kodak Co. useful for black-and-white or color density readings.

Data Recording

One item that every color darkroom worker should have is a notebook. This should be a storehouse of reference. In it, you should write down all pertinent data, such as the filters and exposure times used, emulsions of paper, magnification—almost anything you do in the darkroom. This is so that the next time you go to work, you will be able to check back and find out how you printed such and such a negative or such and such an emulsion. An accurate up-to-date notebook is worth many dollars in time and money. If a particular print doesn't turn out right, and you have kept an accurate record of what you did, you probably can trace back and find out what caused the print to turn out badly.

Fig. 1-13. Macbeth Prooflite Viewer having a color temperature of about 5000 Kelvin.

Viewers

Finally, I wish to cover viewers for viewing both transparencies and color negatives, and also a method used for viewing color prints. The Macbeth Company manufactures a transparency viewer (fig. 1-13) that has a light not as yellow as an ordinary tungsten lamp or as blue as daylight, but somewhere in the middle, which is described as about 5000 Kelvin color temperature. You always have a problem viewing prints or transparencies, for under different conditions you see different results. The transparency looks different under a viewer with an ordinary tungsten lamp than it does under the Macbeth viewer.

Similarly, color prints look different under various sources of illumination. Probably the best way to make your color prints is to make them under the kind

of light in which you intend to view them; but since prints are viewed in many different ways, it is best to set up some kind of standard conditions to work under. There are viewers available for color prints, although some of these are quite expensive. Probably for the amateur color worker, the most inexpensive setup is to get some 100-watt blue-coated tungsten lamps and to shine a couple of them down on a viewing stand or surface. The use of a tungsten lamp is important, because it emits quantities of all wavelengths of radiation in the visible spectrum. Most fluorescent sources are unsatisfactory for viewing color prints. It has only been in recent years that successful efforts have been achieved in producing fluorescent sources, and as yet they aren't widely distributed on the market.

Miscellaneous

An item to be added to the equipment of the exposing darkroom is a device called a "focuser," which is used to help you focus the image, especially when you have a large magnification and the level of light is low.

A film sponge is useful for both the film and paper processing. Another necessary item is some means of removing any dust that may be on your negative. The easiest way to do this is by means of a camel's hair brush or some other soft, lintless object. You might also blow the dust off with a tiny blast from a can of compressed air.

Many new devices have come out on the market to make paper processing easier. They can be manually operated or highly sophisticated and electrically powered. The costs range from $16.95 for a Colourtronic Daylight Processor (for 8″ × 10″ prints) to $375 for a Kodak Model 11 Drum Processor. These prices may change, depending upon the economy. Some of these processors can be used in room light, whereas others must be operated in darkness.

You now see that there is a great variety of equipment available for the processing darkroom and for the exposing darkroom. Although the areas here are separated into two parts, there is no reason why one darkroom cannot be used for both functions. It is up to the color worker himself to decide the extent of his needs and what equipment he needs to achieve his aim. Color printing can be done rather inexpensively, but if one desires, a large amount of money can be spent in equipping a color darkroom. It depends upon you and what you want.

2

EXPOSING THE COLOR NEGATIVE

Briefly, a color negative is similar to a black-and-white negative, except that the color negative records the colors of the subject with the use of three dye images rather than a single neutral silver image. Where you generally have one emulsion layer in a black-and-white negative, you have three emulsion layers in a color negative. Color negatives such as those from Kodacolor II and Vericolor II Professional Films have an orange-appearing mask built into them to provide a measure of color correction. If you could remove this mask from a color negative, you would see the subject recorded in complementary colors. Now what do we mean by complementary colors?

The diagram in fig. 2-1 shows a series of complementary colors. If you work from one side through the center to the other side, the colors across from each other are complementary: blue and yellow, green and magenta, red and cyan. Cyan is a blue-green color and magenta is a reddish purple color. Any set of complements will absorb each other. In other words, yellow absorbs blue light, magenta absorbs green light, and cyan absorbs red light. Cyan, magenta, and yellow are known as the subtractive primary colors. They are the complements of red, green, and blue—the additive primary colors. These combinations can also be stated conversely. You should consider the circle as containing many colors, not just the six mentioned. Every point on the circle is a color of a different hue. Some point between the red and yellow is an orange, and its complement is somewhere between the blue and cyan. We could give many examples of complements, but they all work in the same manner.

THE COLOR NEGATIVE

If we should take a cross-section of Kodacolor II Film, we would find there are many layers. Fig. 2-2 shows a schematic drawing of a typical color negative. Notice that there are three light-sensitive emulsion layers. Following the layers

29

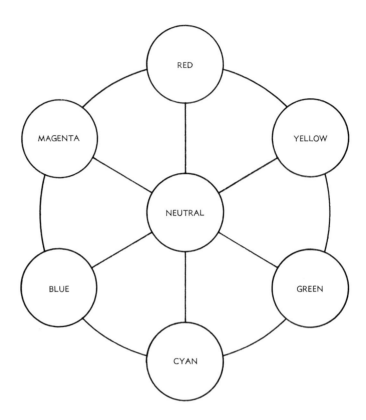

Fig. 2-1. Color wheel of additive and subtractive primaries.

from the base upwards, next to the base is a material called subbing. This material is the adhesive between the emulsions and the film base. Next is the first emulsion layer, which is sensitive to red and blue light. Then there is a clear layer, followed by a layer that is sensitive to green and blue light, and next a yellow filter. The top emulsion layer is sensitive only to blue light. Gelatin coatings on top of the emulsions provide a measure of protection against abrasions.

All of the emulsion layers are sensitive to blue light, but since we want to record only the red, the green, and the blue parts of the subject, the film manufacturer must somehow prevent blue light from reaching the bottom two sensitive layers. This is done through the use of the yellow filter between the top and middle light-sensitive layers. The yellow filter effectively blocks or absorbs blue light, thereby preventing it from reaching the two bottom blue sensitive layers. The yellow filter layer and clear gelatin interlayer also act as separators to keep the emulsion layers apart, which helps prevent interaction during processing.

One thing, perhaps, that you don't realize is the thinness of the coatings on a sheet of color film. There may be ten or more coatings, and each coating may be about 1/10,000-inch thick, much thinner than a human hair.

To summarize, there are three light-sensitive layers in the film; one records red light reflected from the scene photographed, one records green light, and one records blue light.

Exposing the Color Negative

When you load your camera with color negative film and then click the shutter, the film makes a recording of the subject. Just how does it do this? The three sensitive layers record the three primary colors separately onto the three sensitive layers in terms of the red, green, and blue brightnesses of the scene.

Color photography gives its best to the careful worker. All of the materials and equipment available to the color worker should be treated with care. No rough handling.

Should a person follow a different procedure when he uses color film than when he uses black-and-white film? No, not if he is a careful black-and-white worker—he will use the same techniques. What are some of these techniques? For one thing, the photographer sees that his camera is clean, free of any dirt and grit. He is also careful when he loads and unloads his camera to see that he

Fig. 2-2. Cross-section of a sheet of color negative film.

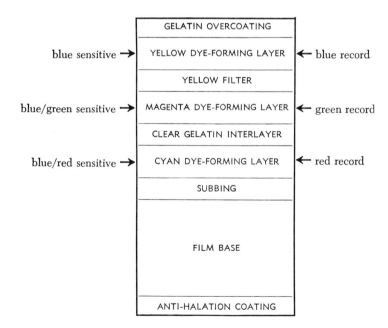

doesn't let light into the roll, and ruin the pictures. Color film should be kept in a cool, dry place before exposure. If you keep your film in the refrigerator or freezer, be sure you allow it to come to room temperature before opening to avoid condensation on the emulsion. While the film is in the camera, the camera should not be kept in the glove compartment of the car. Any hot, humid place is detrimental to color film. For best results, you should not leave your color film in your camera for months on end between the exposing of the first picture and the finishing up of the roll. The latent image starts to change the moment it is formed (when you click the shutter). Conditions such as high temperature and humidity will accelerate the change. Color film really should be processed as soon as possible after exposure for best results.

Using the Gray Card and Gray Scale

It is helpful to include a gray card and a gray paper scale in the scene so that they will be reproduced in the color negative. They should receive the same illumination as the subject. The gray card can be used as a reference area for reading by a densitometer, in order to determine the filter pack when printing the negative.

The inclusion of the gray scale in the color negative permits you to make a visual evaluation of the exposure. You should be able to distinguish the different steps of the gray scale in a well-exposed negative. In an underexposed negative, the dark steps on the scale (light on the negative) will have no detail and a number of the steps will run together. In an overexposed negative, the light steps on the gray scale (dark on the negative) will run together. Satisfactory color prints can often be made from overexposed color negatives, whereas underexposed color negatives are useless for color printing.

You can also use the gray card for making reflection exposure readings. Hold the card so that it faces halfway between the main light source and the camera. Hold the meter about 6 inches away from the gray card when taking the reading. Be careful not to cast a shadow on the card. If you do, the shadow must not be allowed to affect the meter reading.

LIGHT SOURCES FOR COLOR

Daylight

Excellent pictures can be taken during the period from two hours after sunrise to two hours before sunset. The best pictures are made when you have sunlight available. The color quality of daylight changes as the hours progress through the day. The illumination is warmest during the early and late hours.

Photoflood

A highly efficient tungsten lamp of approximately 3400 Kelvin color temperature, which produces lots of light but is short lived.

3200 Kelvin Tungsten Lamps

This is a tungsten lamp designed for use with tungsten-type reversal films and studio color negative film. It is quite stable and long lived, available in 500-watt and larger sizes.

Clear Flash

A flashbulb that produces a color quality of light about 3800–4000 K. Many sizes are available for use with film intended for short exposures.

Blue Flash

A blue-coated flashbulb that is designed to approximate daylight-type illumination. It is ideal for use in synchro-sun work as a fill-in to eliminate harsh shadows.

Electronic Flash

This is a very short, high intensity flash tube approximating daylight in quality. It is designed for use with color negative films intended for short exposure or daylight-type reversal films.

Fluorescent Lamp

Generally not recommended for color work, because the results are not predictable. Although a fluorescent lamp may be rated with a color temperature, the photographic effect will not be the same as if you had used a tungsten lamp of the same color temperature.

KODAK COLOR NEGATIVE FILMS: TYPES AND AVAILABILITY

Kodak Vericolor II Professional Film 4107, Type S

This is a professional sheet film designed to be exposed under lighting conditions where 1/10 sec. or shorter exposure times are possible. This film *must not* be used with long exposure times. It is manufactured with a dimen-

sionally stable .007-inch Estar Thick Base. Many sizes of sheet film are available: 2¼" × 3¼", 4" × 5", 5" ×7", and 8" × 10".

Kodak Vericolor II Professional Film, Type S is also available in roll-film formats such as 135, 120, 220, and in long rolls in the following widths: 35mm, 46mm, 70mm, and 3½-inch.

Kodak Vericolor II Professional Film 4108,Type L

This is a professional sheet film designed to be exposed under lighting conditions where exposure times of 1/50 sec. to 60 seconds are possible. This film *must not* be used with short exposure times. Many sheet film sizes are available: 2¼" × 3¼", 4" × 5", 5" × 7", 8" × 10", and 11" × 14". This film is also available in the 120 roll-film format.

Kodacolor II

A similar film, Kodacolor II, is also available in the amateur roll films that may be used under all varieties of lighting conditions—daylight, electronic flash, flashbulb, or tungsten illumination. It is available in the following sizes:

Roll size	Exposures	Picture size
110	12 or 20	13 × 17mm
116	8	2½" × 4¼"
120	16	1⅝" × 2¼"
	12	2¼" × 2¼"
	8	2¼" × 3¼"
126	12	26 × 26mm
127	16	1³⁄₁₆" × 1⁹⁄₁₆"
	12	1⅝" × 1⅝"
	8	1⅝" × 2½"
616	16	2½" × 2½"
	8	2½" × 4¼"
620	16	1⅝" × 2¼"
	12	2¼" × 2¼"
	8	2¼" × 3¼"
828	8	28 × 40mm
135	20 or 36	24 × 36mm

Techniques for Use

Kodacolor II and Vericolor II Professional Film, Type S, are designed for exposure in daylight or with blue flashbulbs. However, for best results use the following filter recommendations:

Light Source	Exposure Index	Use of Wratten Filters
Daylight	100	None
Photolamp (3400 K)	32	80B
Tungsten (3200 K)	25	80A
Blue flashbulbs	—	None

BLUE FLASH EXPOSURE GUIDE NUMBERS: NO FILTER IS NECESSARY OVER LENS

For Cameras with Between-the-Lens Shutters				For Cameras with Focal-Plane Shutters
Synchronization: X or F		M		
Exposure Time (seconds)	M2B Bulb	No. M3B, 5B, 25B Bulbs	No. 2B or 22B Bulbs	No. 6B or 26B Bulbs
1/25–1/30	130	190	240	190
1/50–1/60		180	220	150
1/100–1/125		150	190	100
1/200–1/250		120	140	70

Electronic Flash Guide Numbers

You should determine your flash unit's output and then expose a test roll using the following guide numbers. Examine the processed roll carefully and decide if the correct guide number was used. Make adjustments by increasing the guide number if the negative is too dense or decreasing the guide number if the negative is too light. Use 1/50 sec. or faster shutter speed.

EFFECTIVE CANDLEPOWER SECONDS OUTPUT/Guide Number

500	700	1000	1400	2000	2800	4000	5600	
50	60	70	85	100	120	140	170	= Guide Number for Kodacolor II or Vericolor II Professional Film, Type S.

Using Guide Numbers

Measure the distance of the lamp to the subject and divide this number into the guide number. Your answer is the aperture setting of your lens. Example: Distance is 10 feet. Guide number for lamp you are using is 50. 50 ÷ 10 = 5. Set lens at $f/5$. If your subject is dark colored, open the lens one stop from your calculations. If the subject is light colored, close down one stop.

The following exposure recommendations should be followed for exposing Vericolor II Professional Film, Type L:

Light Source	Filter No.	Exposure Time	Effective Speed
	None	1/50 to 1/5 sec	ASA 80
	None	1 sec	ASA 64
Tungsten (3200 K)	None	5 sec	ASA 50
	CC10Y	30 sec	ASA 32
	CC20Y	60 sec	ASA 25
Photolamps (3400 K)	81A	1 sec	50 (with filter)
Daylight	85B	1/50 sec	50 (with filter)

Judging Color Negatives

How do you know if your color negative has received enough exposure? You should look at the shadow areas of the subject (in the negative) and see if there is sufficient detail. No detail suggests that the negative is underexposed. An overly dense negative suggests that the negative is overexposed. If you are ever in doubt about the exposure to give, use a little more than what you have calculated. Excellent prints can be made from color negatives that have up to 2 stops overexposure, but only about ½ stop on the underexposed side.

FACTORS TO CONSIDER

1. *Bellows Extension.* If you are taking a picture of an object where the camera is closer than 8 times the focal length of the lens, you can be sure you will need to increase your exposure over the normal. How much change should you make? Measure the length of the bellows from the front of the lens to the film plane. Use the following formula:

$$\frac{B^2}{F^2} = \text{Exposure Factor}$$

B = bellows extension
F = focal length of lens

Example: 10-inch lens and 20-inch bellows extension.

$$\frac{(20)^2}{(10)^2} = \frac{400}{100} = 4X \text{ factor}$$

If your exposure was 1/50 sec. at $f/11$, then the new exposure would be 1/50 sec. at $f/5.6$. You could also arrive at the same calculation by dividing the film speed by 4 and using the new setting on your meter.

2. *Reciprocity Factor* (for Vericolor II, Type L). If you increase or decrease the *time* of exposure for Type L film, then you must adjust the exposure in order to obtain the same result. The manufacturer makes this easy by supplying different exposure indexes for different exposure times.

Processing

Vericolor II and Kodacolor II films utilize Process C-41 and are developed in Kodak Flexicolor Chemicals. These films may be processed by commercial finishing laboratories or by the individual photographer.

Storage of Processed Film

Color films contain dye images, and although the film manufacturers try to have the best dyes available, the dyes are not permanent. The images will fade in time, and the fading will be accelerated if you mistreat the film. DO:

1. Keep processed films away from ultraviolet radiation (sunlight). UV radiation will bleach the dyes.
2. Store the color negatives in a dark, cool, dry place.
3. Keep the color negatives away from harmful gases, such as hydrogen sulfide (H_2S).
4. Keep the processed film in sleeves (preservers).
5. Handle the color negatives carefully by touching only the edges. If necessary use cotton gloves.

TIPS FOR GOOD SHOOTING

1. Keep your film in a cool, dry place prior to exposure.
2. Expose the film before the expiration date.
3. Have the film developed as soon as possible after exposure.
4. Do not mix lights of different color temperature in the same picture. Example: Don't use clear flash lamps and daylight in the same picture, or daylight and tungsten lamps.
5. If you are not quite sure of the exposure, make it a little more than what you have calculated (for color negative work).
6. Try to have a reference area or a reference object in your picture. This might be a gray card, a flesh tone, or some object of a neutral tone.
7. When shooting close-up, allow for bellows extension. Your exposure will be greater than normal.
8. When making exposures shorter or longer than normal, allow for the reciprocity law failure. (This requires a change in exposure from the normal.)
9. If you expose different types of color negative materials, such as Kodacolor II and Vericolor II, Type L, try to balance the film for easy printing. Use the filters recommended.
10. Do not expose Vericolor II, Type L, for short exposure times nor Vericolor II, Type S, for long exposure times and expect to get good results.
11. When removing film from the freezer or refrigerator, allow it to come to room temperature before you open the package.

3

PROCESSING THE COLOR NEGATIVE

After you have exposed your color film, the invisible images on the film must be processed to change them to visible dye images. Black-and-white films are relatively easy to process, and color films are not that much more complicated to process, although greater care must be taken.

Kodacolor II and Vericolor II films will not stand rough handling. For this reason, it is best to give them the "kid glove" treatment. Extra care given to processing details will help insure good color photographs.

THE PROCEDURE

Compared with black-and-white processing, you have more solutions to contend with in color processing. The solutions must be carefully mixed, and you must observe the restrictions on temperature variation for the process. By following the rules and not trying to cut corners, it is possible to achieve the satisfaction of turning out good color negatives.

Precautions in Mixing Chemicals

Some of the chemicals in color kits may cause skin irritations to those persons who may be sensitive to these chemicals. Therefore, it is wise to take the precaution of using rubber gloves while mixing color chemicals. In the event, however, that the skin does contact any of the solutions or solid chemicals, you should wash at once with one of the acid hand cleaners such as:

pHisoderm (Winthrop Laboratories, Inc.)
pHisoHex (Winthrop Laboratoriesn Inc.)
pH6 (Stepan Chemical Co.)
Sulfo Hand Cleaner (West Chemical Products, Inc.)

After using the hand cleaner, rinse the skin with plenty of water. If you do use rubber gloves, make sure they are clean before starting to work. They should be rinsed out and dried. Clean the surface of your gloves before removing them from your hands. One type of glove that I have found particularly useful is the lined glove like those made by the Playtex Company. They are easy to put on and take off, which is an advantage over the skin-type rubber glove. Cleanliness should be one of the chief rules in mixing solutions. All containers and articles used in mixing should be clean. All spilled chemicals, liquids, and powders should be thoroughly cleaned up, for there is nothing worse than to have any color solution contaminated somewhere along the line by carelessness during mixing. You should also provide adequate ventilation when mixing the solutions, especially when mixing the stabilizer, which contains formaldehyde.

Contamination of Solutions

Be sure to clean processing reels, racks, and tanks thoroughly after each use. Avoid the contamination of one chemical solution by any other. It is best to use the same tanks for the same solutions each time and to make sure that each tank or other container is thoroughly washed before it is refilled. This is imperative, since the photographic quality and life of the processing solutions depend upon the cleanliness of the equipment in which the solutions are mixed, used, and stored.

MIXING THE CHEMICALS FOR THE KODAK FLEXICOLOR PROCESSING KIT FOR PROCESS C-41

The 1-Pint Size

The contents of this processing kit produce enough solutions for mixing two 1-pint quantities of color developer and 1 pint each of bleach, fixer, and stabilizer. The reason for two sets of color developer is that the bleach, fixer, and stabilizer process twice the quantity of film as the other two solutions. The complete processing line of Process C-41 is four solutions.

Mixing Directions and Precautions

If you have only one container to mix the solutions in, mix them separately in the order of color developer, bleach, fixer, and stabilizer. Make sure that the mixing container is thoroughly rinsed out before each successive solution is

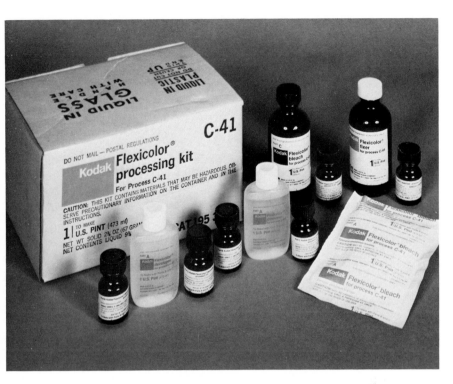

Fig. 3-1. The Kodak Flexicolor Processing Kit for Process C-41,
1-pint size. The kit contains two units of developer and one each
of the bleach, stabilizer, and fixer.

mixed. As you are mixing, rinse each solution container (bottle) and add the
rinse to the mixing container (beaker or other device).

WARNING: The kit for Process C-41 contains materials that may be
hazardous. Read and observe the instructions given on the containers and those
packed with the kit.

The Color Developer

In the 1-pint kit, a unit of color developer consists of three bottles of
liquid, parts A, B, and C.

1. Start with 11 fluid ounces (325 ml) of water at 80–90 F (27–32 C).

2. While stirring, add the contents of the bottle, part A. Mix the two
liquids together thoroughly.

3. While stirring, add the contents of the bottle, part B. Mix well.

4. While stirring, add the contents of the bottle, part C. Mix well.

5. Add sufficient water to bring the volume of the developer solution to 16
fluid ounces (473 ml). Stir until uniform.

The color developer is now ready for use. Do not mix the second set of developer components until you have exhausted the life of the first pint of developer solution.

Bleach

In the 1-pint kit, a unit of bleach consists of a packet of dry chemicals, part A, and two bottles of liquids, parts B and C.

1. Start with 11 fluid ounces (325 ml) of water at 80–90 F (27–32 C).
2. While stirring, add the contents of the packet, part A, and stir until the chemicals are completely dissolved.
3. While stirring, add the contents of the bottle, part B. Mix well.
4. While stirring, add the contents of the bottle, part C. Mix well.
5. Add sufficient water to bring the volume of the bleach solution to 16 fluid ounces (473 ml). Stir until uniform.

Fixer

In the 1-pint kit, a unit of fixer consists of one bottle of liquid.

1. Start with 11 fluid ounces (325 ml) of water at 70–80 F (21–27 C).
2. While stirring, add the contents of the bottle of liquid. Mix well.
3. Add sufficient water to bring the volume of the fixer solution to 16 fluid ounces (473 ml). Stir until uniform.

Stabilizer

In the 1-pint kit, a unit of stabilizer consists of one bottle of liquid.

1. Start with 11 fluid ounces (325 ml) of water at 70–80 F (21–27 C).
2. While stirring, add the contents of the bottle of liquid. Mix well.
3. Add sufficient water to bring the volume of the stabilizer solution to 16 fluid ounces (473 ml). Stir until uniform.

The 1-Gallon Size C-41 Components

The mixing of the solution for 1-gallon size units is similar to 1-pint size (fig. 3-1), except for the increased amounts of water and chemicals to be dissolved. If you use this size follow the packaged instructions carefully.

THE REACTIONS THAT OCCUR IN COLOR PROCESSING

Developer

Two reactions occur in the color developer. First, the exposed silver halides (the invisible latent images) are changed to metallic silver, and in the course of this reaction oxidation products are produced. Second, these oxidation products react with the color couplers found in the various layers of the color film, and the color couplers change to their respective dyes—cyan, magenta, and yellow. At a given processing time and at a given temperature, all three dyes images come into balance. Therefore, when you print the color negative, where you have photographed whites, grays, and blacks they will print as white, gray, and black, and not as white, blue-gray, and yellowish black.

1. Silver halide (latent image) + color developing agent = metallic silver (Ag image) + halide + oxidized color developer
2. Oxidized color developer + dye coupler = dye image

At this stage in the process, you will find a silver negative image and a dye negative image in each emulsion layer.

Bleach

The bleach stops the action of the developer. Then the oxidizing agents in the bleach change the metallic silver images into silver halide images for later reaction with the fixer.

Metallic silver images + halide bleach = silver halide + complex bleach by-products

Fixer

The fixer changes the silver halides in each layer to soluble silver salts. Most of these salts come out of the film into the fixer.

Wash

The wash water removes the chemicals retained by the emulsion layers in either the bleach or fixer steps.

Stabilizer

The stabilizing bath with a wetting agent improves the stability of the dye images and allows for uniform drying of the film surfaces.

THE CAPACITY OF THE SOLUTIONS

Each pint of developer will process the number of rolls listed below:

18 rolls 110-12 exposures 8 rolls 135-20 exposures
15 rolls 110-20 exposures 6 rolls 135-36 exposures
10 rolls 126-12 exposures 10 rolls 828 exposures
6 rolls 126-20 exposures 4 rolls 620/120 exposures

Since you are trying to obtain uniform processing in all of your rolls of film, you will find that you should increase the developing time for each successive roll. The following table lists the increases in time for the different sizes of Kodacolor II and Vericolor II roll film.

TABLE FOR DEVELOPMENT-TIME COMPENSATION

Film Size	Rolls per pint of developer, before time increase	1st Process	2nd Process	3rd Process	4th Process	5th Process	6th Process	*Rolls
			(time in minutes and seconds) for the 1-pint kit					
110-12	3	3'15"	3'20"	3'26"	3'31"	3'37"	3'43"	18
110-20	3	3'15"	3'22"	3'30"	3'37"	3'45"	NR	15
126-12	2	3'15"	3'21"	3'28"	3'36"	3'45"	NR	10
126-20	2	3'15"	3'25"	3'37"	NR	NR	NR	6
135-20	2	3'15"	3'23"	3'33"	3'45"	NR	NR	8
135-36	2	3'15"	3'29"	3'47"	NR	NR	NR	6
828	2	3'15"	3'19"	3'24"	3'30"	3'37"	NR	10
620/120	1	3'15"	3'27"	3'42"	4'00"	NR	NR	4

NR = Not Recommended.
*Rolls = Discard solution after developing this number of rolls per pint. *Other* solutions can be used with *twice* as much film.

When you have reached the point where the developer and stop bath have been exhausted, mix the second developer and stop-bath components and start over again according to the times in the table. Do not discard the bleach, fixer, or stabilizer when the first pint of developer becomes exhausted. Remember these three solutions can process twice the quantity of the color developer.

STORAGE OF SOLUTIONS

For the best results, processing solutions should be mixed shortly before use. If necessary, however, unused or partially used developer solution can be kept for six weeks in a full, tightly stoppered bottle. The other processing solutions, unused or partially used, can be kept in full, tightly stoppered bottles for eight weeks.

Make sure that any containers in which the solutions are to be stored are thoroughly clean. You may want to store the solutions in brown or amber-colored bottles, although clear glass bottles may be used. Probably the handiest bottles now available are of the polyethylene type. These bottles are unbreakable, and therefore offer a measure of protection not available with glass bottles.

PREPARATIONS FOR PROCESSING

Loading the Exposed Roll Film in the Tank

You should be familiar with the procedure for loading your processing tank. If necessary, obtain an old film and practice loading. The film should be loaded evenly without any buckling or sticking. Develop a technique of loading your tank smoothly and evenly.

Color films should be handled in total darkness. You will have to orient yourself and your equipment so that you can find any item you need quickly. After you have loaded your film, secure it (make it light safe) and then turn on the white lights.

Getting the Solutions Ready

1. Place the bottles containing the solutions in a water jacket at 100.5 F. The temperature of the solutions must be within the tolerances before beginning.

2. Have the bottles in order so you won't have to hunt for each solution.

Agitation

Be sure to agitate as recommended. Improper agitation may cause areas of uneven color in prints from the negatives.

Developer

Pour the developer quickly into the tank. When using roll-film reel tanks, as soon as the film is wet with developer, tap the reel gently on the bottom of the tank several times to dislodge any air bubbles. Turn the tank over vigorously and rapidly, if this type of agitation can be given without spilling the solution. If not, rotate the tank or reel in one direction and then the other. With the developer, agitate continuously for the first 30 seconds. For the balance of the time, agitate for 2 seconds every 13 seconds by turning the tank over and back or by rotating the tank or reel in both directions. Tanks that can be inverted are recommended. Between each agitation cycle, place the developing tank in the water bath so as to maintain the proper processing temperature.

Bleach and Fixer

Pour the bleach or fixing solution into the tank and agitate for the first 30 seconds. Agitate vigorously, using the same method as for the developer. For subsequent agitation, agitate for 5 seconds every 30 seconds.

Stabilizer

Pour the stabilizer solution into the processing tank and agitate the reels for 30 seconds. No agitation is required for the remainder of this step.

Wash

Running water of proper temperature is preferred. However, films can be washed by one change of fresh water per minute. In this latter case, agitate the film in the wash.

Drying

Remove the film from the reels and hang it up to dry for 10 to 20 minutes at 75–105 F (24–41 C) in a dust-free atmosphere with adequate air circulation.

If a drying cabinet is used, the air should be filtered and its temperature must not exceed 110 F (43 C). Increase the relative humidity if excessive curl is encountered.

Timing

The time of each processing step includes the time required to drain the tank. This varies, depending on the construction of the tank and whether the cover is on or off. In each case, start draining in time to end the processing step (and start the next one) on schedule. I will assume you can drain your tank within 10 seconds.

PROCESSING—KODAK PROCESS C-41

1. *Color Developer* (100 F ± ¼ F)—3¼ minutes. *The developing time depends upon how many films have been processed in the developer.* Check the previous table for the correct time. Start the timer as you start to pour the developer rapidly into the tank. Agitate for the first 30 seconds and thereafter as directed. The agitation method will depend on the type of tank you have. Either the film is rotated, or the tank is tipped back and forth.

Have a funnel ready for returning the developer back to its bottle. Be careful when pouring, so that you do not splash or spill any of the solutions.

Ten seconds before the end of the time period, pour the developer into its bottle. Advance the timer 6½ minutes.

2. *Bleach* (75–105 F)—6½ minutes. Pour the bleach into the tank quickly. Agitate for the first 30 seconds and thereafter as directed. Drain for the last 10 seconds of this step. Remove the cover of the tank and leave it off for the remainder of the steps. Advance the timer 3¼ minutes.

3. *Wash* (75–105 F)—3¼ minutes. Place the reel in running water. Rinse out the tank thoroughly. Drain the reel for the last 10 seconds and then place it back in the tank. Advance the timer 6½ minutes.

4. *Fixer* (75–105 F)—6½ minutes. Pour in the fixer. Agitate for the first 30 seconds and thereafter as directed. Drain for the last 10 seconds of this step.

5. *Wash* (75–105 F)—3¼ minutes. Place the reel in running water. Advance the timer 1½ minutes.

6. *Stabilizer* (75–105 F)—1½ minutes. Place the reel in the solution. Agitate for 30 seconds. Drain.

7. *Dry* (not over 110 F). Remove the film from the reel and hang it to dry in a dust-free atmosphere. Sponging should not be necessary if all the solutions, including the wash water, are free of dirt particles.

PROCESSING SHEET FILM: VERICOLOR II, TYPE L AND TYPE S, WITH REPLENISHMENT

Processing sheet film requires a different technique than that for roll film. For one thing, you are working in the dark during the first three steps (developer, stop bath, and hardener). For processing sheet color negative film you need a tank setup. The minimum number of tanks required is three tanks plus a wash tank. This requires you to use the same tanks for different solutions. You may prefer to have a different tank for each solution. In this case, you need five solution tanks plus a wash tank.

You can process in ½-gallon tanks, but it is much easier to work with larger sizes. 4″ × 5″ 1-gallon tanks may be used or the 8″ × 10″ 1-gallon tank using 4″ × 5″ multiple hangers. A tank setup similar to fig. 5-1 can be used, or you can set the tanks in a sink. A standpipe permits water to surround the tanks and act as a water jacket.

Agitation

Use the lift-and-tilt method of agitation. On entering the developer, tap the hangers against the tank wall to remove any air bubbles that may have formed. During the first 15 seconds of development:

1. Lift the hangers out.
2. Tilt them 60 degrees so you are draining by one corner, but do not drain.
3. Quickly reimmerse them.
4. Lift the hangers out again.
5. Tilt them 60 degrees so you are draining by the opposite corner, but do not drain.
6. Quickly reimmerse them.

Repeat the above cycle every minute in the developer. Drain the hangers for the last 10 seconds of each processing cycle. The agitation in all the remaining solutions is:

1. Lift the hangers up and down for the first 15 seconds.
2. Lift and drain the hangers once each minute. Drain from one corner. The next time drain from the other corner, and so on.

Replenishment

When processing sheet film in a ½-gallon tank or larger tank setup, you must replenish the solutions in order to obtain consistent results. Replenishment means adding specially prepared developer, bleach, and fixer solutions to your working solutions in the tank. Unfortunately, some of the replenishing

solutions are only available in 5-gallon sizes and are quite expensive. Unless you intend to do a lot of processing, it does not pay to use replenishment.
Replenishment per 4″ × 5″ film in milliliters:

Developer	33ml
Bleach	28ml
Fixer	28ml
Stabilizer	28ml

Procedure: Mark the level of the solutions when you first pour them into the tank. Upon completion of processing, calculate the amount of replenisher you have to add to each solution. Dip out of the tank an amount of solution equal to the amount of replenisher to be added. Add the replenisher, and then add some of the old solution to bring the level up to the mark, since some of the solution is lost as film is processed.

Exhaustion Method

If you do not plan to replenish the solutions, you can use them to exhaustion. You can process the following total amounts of film in each gallon of solution. The solutions should be thrown away after the exhaustion quantity is reached.

Developer	32	4″ × 5″ sheets / gallon
Bleach	64	4″ × 5″ sheets / gallon
Fixer	64	4″ × 5″ sheets / gallon
Stabilizer	64	4″ × 5″ sheets / gallon

PROCESSING TIPS

1. Be very careful in handling the hangers and in pouring solutions, so you do not splash any of one solution into another. This contamination *must* be guarded against.
2. Agitate faithfully in *all* solutions. Consistency is not only desirable but necessary.
3. Keep careful records of your processing because the processing times change with increased use.
4. Dry in a warm dust-free area.

5. Small quantities of the fixer or stop bath in the color developer seriously impair the negative quality. The best procedure is to use the same tanks for the same solutions each time (especially the developer) and to make sure that each tank is thoroughly washed out before it is used.

6. You will notice that the film has an opalescent appearance while wet. This is normal. The film will clear as it dries.

7. Carefully read the instruction sheets packed in the film boxes and with the processing solutions. Changes are constantly being made, so you must make sure you are following the latest instructions.

SUMMARY OF STEPS FOR KODAK
FLEXICOLOR PROCESSING KIT FOR PROCESS C-41

Solution or Procedure	Remarks	Temp (F)	Temp (C)	Time in Min*	Total Min at End of Step
1. Developer	Total darkness	100 ± ¼	37.8 ± 0.15	3¼	3¼
2. Bleach	Total darkness	75 – 105	37.8 ± 3	6½	9¾
Remaining steps can be done in normal room light					
3. Wash	Running water**	75 – 105	37.8 ± 3	3¼	13
4. Fixer		75 – 105	24 – 41	6½	19½
5. Wash	Running water**	100 ± 5	37.8 ± 3	3¼	22¾
6. Stabilizer		75 – 105	24 – 41	1½	24¼
7. Dry	See instructions below	75 – 105	24 – 41	10 to 20	

*Includes 10-second drain time in each step.
**Use fresh water changes throughout the wash cycles. Fill the processing tank as rapidly as possible from a running water supply. When full, agitate vigorously for about 2 seconds and drain for about 10 seconds. Repeat this full wash cycle. If desired, use a running water inflow-overflow wash with the cover removed from the tank.

4
WORKING WITH EKTACOLOR 37 RC PAPER

CHARACTERISTICS

Ektacolor 37 RC Paper is designed for making prints from Kodacolor-X, Kodacolor II, Ektacolor, and Vericolor negatives. It is an integral tripack on a resin-coated paper base with three light-sensitive emulsions. The emulsion layer order is not the same one found in most camera color films, but is as below:

Sensitivity	
Red →	CYAN DYE-FORMING LAYER
Green →	MAGENTA DYE-FORMING LAYER
Blue →	YELLOW DYE-FORMING LAYER
	RESIN-COATED PAPER BASE

Ektacolor 37 RC Paper is of the protected coupler type, as are the Kodak color negative films. When the emulsions are wet, you can clearly see the cyan dye image, and the print looks dark and off-color (cyanish-blue). This darkness and off-color clear up as the print dries. There is no yellow filter between any of the emulsion layers because, for all practical purposes, each layer is sensitive to only one color of light—either red, green, or blue.

This makes it easy to understand how the paper works during exposure. Remember that each layer is sensitive to the complementary color of the dye formed. For example, the more red light the paper receives, the more cyan dye

formed; the more green light, the more magenta dye; the more blue light, the more yellow dye. The reverse is also true: the less red light, the less cyan dye; the less green light, the less magenta dye; the less blue light, the less yellow dye. When you see any certain color cast appearing, you can remember that it was formed by the complementary color of light. The preceding statement indicates how cyan, magenta, and yellow are formed, but what is the color that you see when you have less than normal cyan, magenta, or yellow? Minus cyan would be a red cast on the print, and this would be caused by too much green and blue exposure. A minus magenta would mean that the print had a green cast resulting from too much red and blue exposure. A minus yellow would mean that the print had a blue cast because the paper received too much red and green exposure. You must always think about the exposure of a color paper in terms of these three quantities—how much red, green, and blue light is reaching the emulsions. We will refer to this again when we talk about exposure methods later in the chapter.

Ektacolor 37 RC Paper is a relatively fast paper, and it is sensitive to all colors of light. What does this mean to you? Normally, you will not have to use long exposure times unless you are making very large enlargements. However, it also means that you must change your technique of working with your papers in the darkroom, since you should work in complete darkness. Ektacolor 37 RC Paper may be handled under a Wratten No. 10 safelight, which has a 7½-watt bulb. You will find that you have no difficulty adapting yourself to working in complete darkness and will therefore use a safelight only in times of emergency. When beginning processing, you will find it helpful to use a safelight during the first stages of color development.

Availability

Ektacolor 37 RC Paper is available in many sizes from 8″ × 10″ sheets up through 30″ × 40″. The paper is also available in rolls on special order from your dealer. If you plan to do any quantity of color printing, you should have a sufficient amount of a single emulsion paper in order to set up a standard and go back to this repeatedly with satisfactory results. Ektacolor 37 RC Paper is available in glossy F and semi-matte N surfaces. The F surface gives a high gloss without ferrotyping.

Keeping Qualities of Unexposed Paper

Unexposed color materials are very perishable; high temperature and high humidity both affect the final results. Ektacolor 37 RC Paper is particularly sensitive to temperature change; it should be stored in a cold place when not being used. You should store the paper at 0 F for best keeping conditions, but it may be stored in an ordinary refrigerator, which is colder than 50 F. In the

temperature range from freezing (32 F) to 50 F, the paper changes very slowly. If you use it infrequently, the results from one time to the next may not exactly match. The package, either box or envelope, must be allowed to come to room temperature before using. This takes at least an hour, with the package remaining *unopened* during this time. The purpose of waiting for an hour before opening the paper package is to prevent any condensation of moisture on the light-sensitive emulsions themselves.

Standard Negative

The standard negative is defined as a negative of normal contrast with a good range of tones that will produce a satisfactory print. There may be more than one standard negative, because we look for certain things in this negative. The standard negative may have as its reference area a flesh tone, a gray card, a gray scale, or some neutral tones. You should be able to take this standard negative and repeatedly make good prints from time to time as a check on your procedure, processing, or equipment. It may also be used as a check on different emulsions of paper. This standard negative should be kept under good storage conditions, and it should be handled carefully when used. In the Kodak Color Dataguide, there is a 35mm standard negative that you may use, if you don't have one of your own.

Standardizing Your Enlarger

In order to be able to go into your darkroom time after time and produce acceptable results without a lot of test printing, you must operate under a set of standards. First, you must set up your enlarger in a way that is easily duplicated whenever you wish. I will cover two ways in which this may be done. First, probably the easiest and cheapest way is to fasten a tape measure on the vertical support column of your enlarger. For the Omega enlarger this may be done as in fig. 4-1. The numbers on the tape do not indicate the exact height of the enlarger but only a relative position, so that with a given lens you are able to go back to a given magnification for reprinting a negative without change in exposure from that which you have used previously. If you are making either a larger or a smaller print, you need to know the actual magnification you are working at. Apply the magnification in the following formula:

$$\frac{E_1}{E_2} = \frac{(M_1 + 1)^2}{(M_2 + 1)^2}$$

The formula also depends upon knowing the magnification of your original printing. The formula is based upon a constant f/number—in other words, no change in the position of the lens opening—and also on your using negatives of similar density.

Fig. 4-1. Omega enlarger showing tape on column.

An easy way to determine magnification is to put a transparent ruler with an inch marking on it on the negative carrier of your enlarger. Project this inch marking on the easel in sharp focus and measure the distance between the inch lines. If it measures 2 inches on the easel, then you are at a 2× magnification; if it measures only a half inch, then you are at a .5× magnification. Let us go through a simple illustration to see how the formula works. Suppose that your original test print had a magnification of 2× and the exposure time was 10 seconds. Now in your next printing, you find that the magnification has

changed to 3×, and you want to know what the exposure time should be for the new condition. You would, therefore, substitute the correct values as shown:

$E_1 = 10$ seconds, $M_1 = 2$, $M_2 = 3$, $E_2 = ?$

substituting: $\dfrac{10}{E_2} = \dfrac{(2+1)^2}{(3+1)^2} = \dfrac{(3)^2}{(4)^2} = \dfrac{9}{16}$

solving: $9E_2 = 10 \times 16 = 160$

$E_2 = \dfrac{160}{9} = 18$ seconds approximately;

therefore the new exposure time would be 18 seconds.

Any great change in times might introduce reciprocity failure, showing up as a lighter print than expected. The color balance may also change because of reciprocity law failure within the emulsion layers. These calculations may also be carried out using a Kodak Dataguide computer, which costs a dollar, but still you need to know the magnifications concerned. While working in your darkroom, you should keep careful notes on how you have printed each negative. These should include identification of the negative, the size and kind of negative, the exposure conditions of the negative, if known, the Ektacolor paper emulsion number, the paper filter adjustment (CC filters), the exposure factor, the magnification of the print, the filters used in the enlarger for printing, and the exposure time and f/stops. Records of this sort should be kept in a bound notebook, since loose-leaf sheets are easily torn out and lost. It might happen that the information you need would be on just such a sheet.

The second method of setting up your enlarger requires the use of some type of light meter to measure the intensity on the easel, either with or without the negative in the enlarger. Such a meter is shown in fig. 1-11. A footcandle meter such as the Photo Volt 200A meter (not illustrated) or the Analite meter can be used. One method for using these meters is to set up your enlarger using a negative under the conditions that will produce a good print from that negative. Then remove the negative from the enlarger, allowing all the light to fall on the easel. In the case of the footcandle meter, you put the sensitivity cell in the center of the illuminated area, measure the intensity of the light, and record this in the notebook. For negatives of this same type and density, you then set up your enlarger for this footcandle intensity and will therefore be fairly close to making a satisfactory print. The Analite has a little light that will go out at a certain level of intensity. Take the Analite meter and place it under the center of illumination. Adjust the dial so that the light is on; then very carefully and slowly turn the dial until the signal light gradually gets dimmer and dimmer and at some point goes out. It may be necessary to shade the bulb from the enlarger light so you can see when this point is reached. Note the position of the dial when the sensing light does go out. For negatives with similar density and characteristics, this setting will produce normal prints.

Suppose you're now printing another negative similar to the one used as the standard, except that you are going to print this negative at a different magnification. You set into the enlarger the filtration that was used for the previous standard negative, and then put in the new negative, projecting the image to the size desired. Now remove the negative and place the Analite meter in the illuminated area of the easel. The meter should be set at the position that was recorded previously. Adjust the aperture until the sensing light goes on, and very gradually stop down the lens until the light goes out. This is now the correct aperture for the new negative. If the enlarger is at a greater magnification, you will have a greater lens opening; if the enlarger is at a smaller magnification than for the standard negative, you will have a smaller lens opening.

In any case, for either of these two meters, the light must be able to go on when you place the meter under the illuminated area of the easel. If the light does not go on, no matter how sensitively you have set the instrument, you will not be able to make any measurement.

The Analite or the Photo Volt 200A meter may be used to compare negatives. This can only be done if you have similar areas in the negatives you are printing, compared with areas in the standard negatives. These could be similar flesh tones, gray mid-tone areas, or whites. The second negative, if you are going to compare it with the standard, must have an area in it of a similar nature. To use the meter under this set of conditions, set up your enlarger with your standard negative as if you were making a good print. Now place the sensing mechanism of the meter on or under the area to be measured, such as a highlight of a flesh tone. Turn up the sensitivity of the meter until the light comes on. Very carefully turn the dial until the light goes out and record this position. Now place your new negative in the enlarger and blow it up to the size you desire. Place the sensing cell of the meter under or on the reference area—in this case the highlights of the flesh tone. Open up the lens of the enlarger until the light of the meter goes on. Slowly stop down the lens until the light goes out. At this point, the enlarger is set for printing this negative with the same exposure time that was used for printing the standard negative. If, in the use of the photometer for the new negative, you find that when you open the lens all the way up the light does not go on, you will have to go back to your standard negative and stop down the lens one or two stops. This will change the sensitivity setting of the instrument. You must also remember that in stopping down the enlarger for the standard negative, you must compensate by increasing the exposure time. For each stop increase, you need to double the time of exposure, plus an increase of 1.15 times to allow for reciprocity failure.

Controlling the Color Balance

In white light printing, we use color-compensating (CC) or color-printing (CP) filters. CC filters are optical quality filters and may be used over the lens

or in the optical system as in a color head, but CP filters must be used only in the optical system.

The Eastman Kodak Company lists the following filters as being available:

COLOR-COMPENSATING FILTERS

Cyan	Magenta	Yellow	Red	Green	Blue
CC025C-2	CC025M	CC025Y	CC025R	———	———
CC05C-2	CC05M	CC05Y	CC05R	CC05G	CC05B
CC10C-2	CC10M	CC10Y	CC10R	CC10G	CC10B
CC20C-2	CC20M	CC20Y	CC20R	CC20G	CC20B
CC30C-2	CC30M	CC30Y	CC30R	CC30G	CC30B
CC40C-2	CC40M	CC40Y	CC40R	CC40G	CC40B
CC50C-2	CC50M	CC50Y	CC50R	CC50G	CC50B

COLOR-PRINTING FILTERS

Cyan	Magenta	Yellow	Red
CP05C-2	CP05M	CP05Y	CP05R
CP10C-2	CP10M	CP10Y	CP10R
CP20C-2	CP20M	CP20Y	CP20R
CP40C-2	CP40M	CP40Y	CP40R

CP2B (Ultraviolet absorbing and equivalent to Wratten 2B filter)

Functions of the CC or CP Filters

The duty of the filters is to absorb light. Each color of filter absorbs a certain kind or quality of light.

Filter	Light absorbed or subtracted
Red	Green and blue
Green	Red and blue
Blue	Red and green
Cyan	Red
Magenta	Green
Yellow	Blue

You will notice that the cyan, magenta, and yellow filters absorb only one color of light. For this reason, cyan, magenta, and yellow are called subtractive primaries.

58

One must think of the white light or tungsten lamp in the enlarger as being composed of red, green, and blue light. The above filters inserted into the light path absorb or prevent certain parts of the white light from reaching the easel.

Example: If we want less red light, then we use a cyan filter. If we want less red and green light, then we use a blue filter. If we want less red and green light, with less red than green, then we use a cyan filter and a blue filter together.

Never use filters together that absorb red, green, and blue light (all three).

Example: Never use a cyan filter and a red filter together. Cyan absorbs red, and red absorbs green and blue. Never use a red and green filter together—red absorbs green and blue, and green absorbs red and blue, and so forth.

RULES FOR WORKING WITH FILTERS

1. Adding filters together. If you add filters of similar color then it is a matter of simple addition.
Examples: 1) CC10C + CC10C = CC20C
2) CC30C + CC10C = CC40C
2. If you add filters of different colors, then the amount stays the same, but the color changes.
Examples: 1) CC10M + CC10Y = CC10R
2) CC10M + CC10C = CC10B
3) CC10C + CC10Y = CC10G
3. Neutral density is the combination of filters that absorb equal parts of red, green, and blue.
Examples: 1) CC10C + CC10M + CC10Y = 10 N.D. (neutral density)
2) CC10G + CC10M = 10 N.D.
3) CC10B + CC10Y = 10 N.D.
4) CC10R + CC10C = 10 N.D.

If you have an enlarger that does not have a color head, then you should use CC filters over the lens. Be sure that when you use a filter, you know it optical qualities. At the present time, Kodak Ektacolor 37 RC Paper does no ordinarily require the use of any cyan filtration with correctly exposed nega tives, and therefore the cyan filters are not needed. However, color balance o papers change, and you should be prepared for almost any filter combination. I is desirable to have the red, yellow, magenta, and cyan filters as designated previously. The CP filters are available in the 5-inch square size for about $2.2 a filter. This size is large enough for most color heads, and the filter can easil be trimmed to fit, if necessary. As previously mentioned, there are 40 differen

CC filters available. All of these are not necessary in most color printing work with Ektacolor 37 RC Paper. The filters that you need for the average color printing are the series of red filters, the magenta filters through 30, and the yellow filters. If you want to do some judging of color balance using filters, then you should have up through 20 in each one of the series. The CC filters are presently available in 3-inch square sizes for approximately $2.65 each.

EXPOSURE METHODS

There are two methods for exposing color paper. One of these was covered briefly in the preceding section when we discussed using CC filters. This method is using white light (tungsten lamp) and exposing through CC filters. The other method is using separate red-, green-, and blue-light exposures. These three exposures are made through the proper Wratten filter. The white-light method is used by the amateur and professional alike. The tricolor method can be used by anyone, but is favored by people concerned with photo finishing, since it is easily adapted to automatic printing instruments and equipment.

White-Light Method

This procedure of making a single exposure with a tungsten lamp has several advantages over the tricolor exposure method. It is faster, because there is only a single exposure time. You may do dodging and burning during exposure, and you can do combination printing. However, the control over the quality of the light in white-light printing must be done with the use of the CC or CP filters specifically designed for the purpose.

In making an exposure onto color paper with a white light, we are in essence using red, green, and blue light combined as a single unit. We must think of the light in this manner because the color paper has three emulsions, one sensitive to blue light, one to red, and one to green. The cutaway diagram at the beginning of the chapter shows the order of the various layers in the paper and the sensitivity and the dye produced by each layer. Since these dye images make up the picture that we see in the finished product, it is necessary to control the amount of dye formed in the red-, green-, and blue-record layers (the layers that are sensitive to red, green, and blue light).

Before making any exposures, you must set up your enlarger to some known standard condition. Place your color negative in the enlarger, emulsion side down, and project it so that you will obtain an $8'' \times 10''$ enlargement. Record the height of the enlarger and set the aperture at $f/8$ if you are using a $2\frac{1}{4}$-inch square negative, $f/11$ for a $4'' \times 5''$ negative, and $f/5.6$ for a 35mm

negative. This is provided you are using a 75-watt bulb in your enlarger. If you are using a 150-watt bulb, then stop down one stop from the figures given. You may find that after you have made a test print you want to use a different aperture setting in order to obtain a realistic exposure time. You must be able to repeat your efforts by going back to the settings you have made for your test print. Now place a 50 red filter or its equivalent, which would be a 50 magenta

Fig. 4-2. A color head on the Omega VC enlarger showing position of heat-absorbing glass (position 2) and CP filter (position 3).

Fig. 4-3. The positioning of a CC filter in front of the enlarger lens.

filter plus a 50 yellow filter, in the optical system of the enlarger. Include a *heat-absorbing glass* and a 2B ultraviolet-absorbing filter. If you have CC filters, you may place them under the lens or in a color head, if your enlarger is so equipped. If you use CP filters, do not use them under the lens, but place them in a color head. Figs. 4-2 and 4-3 show how these two positions are used in an Omega 45 VC enlarger.

When your enlarger is ready for printing, take the package of Ektacolor 37 RC Paper and pull the strip on one end. This eliminates any need for using a knife or scissors and also provides an overlapping flap for sealing the package when you are finished. Turn out all the lights in the darkroom and remove the inner envelope. Along with the envelope are a cardboard filler that helps keep the package firm and an instruction sheet. Remove the cardboard. Take out the inner envelope and break the tape seal on the folded end. You can feel several folds on the envelope. Open up the folds and take out one sheet of paper. At this point, it is presumed that the paper has been allowed to come to room temperature. As mentioned before, this will probably require an hour or more after being removed from the freezer or refrigerator. A longer time is required if the paper has been kept at 0 F. Roll up the flap of the inner envelope and place the paper back in the outer envelope. It is handy to have a lighttight

drawer or paper safe or even a large, empty photographic box that can serve a a place to keep the unexposed paper.

Now put the sheet of Ektacolor 37 RC Paper in the easel, and using the cardboard filler that was in the envelope, make a series of exposures across the paper. A likely series of exposure times could be 2, 4, 8, 16, 32, and 64 seconds First, expose the whole sheet for 2 seconds. Then cover a small area with the card and expose 2 more seconds. Covering an additional area, expose 4 more seconds. Next cover an additional area and expose 8 seconds, and so on. You may use your own combination of exposure times, but any series you choose should not run together like 1, 2, 3, 4, 5 seconds. They should be spread apart or doubled as you go along. This first test is to show the approximate area of proper density in the finished print. There should be one area that is either a normal density or an area that is too light adjoining an area that is too dark Suppose that the 16-second exposure time produced a step that is too dark, and the 8-second time one that is too light. This means that the proper exposure time is somewhere between 8 and 16 seconds. If it looks as though it might be about halfway, then try 12 seconds for the next test. If the 8-second step is just little too light, try 10 seconds; or if the 16-second step is just a little too dark, try 14 seconds. If the test print turns out too dark in all steps, then you have given too much exposure overall, and you need to stop down the lens. If the print is too light overall, then you need to open up the lens. Where you have a print turning out with no images at all, look for causes other than exposure, for in the series of exposures recommended, some image should result.

After exposing the paper, place it in a lighttight container. Once the paper has been secured, the white lights may be turned on in the darkroom and preparations made for processing. The manufacturer might recommend the use of a No. 10 safelight filter in the darkroom while handling Ektacolor 37 RC Paper. However, I think you will find that, at least during the exposure of the paper, you are in a much safer situation if you work in total darkness.

Tricolor Printing

This method of exposure involves the use of three filters only—a red, a green, and a blue. You control the cyan, magenta, and yellow images by the appropriate amounts of red, green, and blue light. The more red light, the more cyan the image becomes; the less red light, the less cyan is formed, etc. The following filters are required:

For red exposure	Wratten No. 25
For green exposure	Wratten No. 99
For blue exposure	Wratten No. 98

A typical trial exposure would be red: 4 seconds; green: 15 seconds; and
blue: 5 seconds with a 2× magnification and a 75-watt lamp, and the aperture
set at $f/5.6$. Use heat-absorbing glass in the enlarger.

You must make some provision for holding the filters over the lens. You
also need a timer that can be reset in the dark.

Procedure

Place the negative in the enlarger and make a 2× blow-up. Focus wide
open, then stop down to $f/5.6$. Place the red filter over the lens and set the
timer for 4 seconds.

Turn out the lights. Place a sheet of Ektacolor 37 RC Paper in the easel.
Make the red exposure. Do *not* move the easel or enlarger during the series of
exposures.

Remove the red filter and replace with the green filter. Set the timer for 15
seconds. Make the green exposure.

Remove the green filter and replace with the blue filter. Set the timer for 5
seconds. Make the exposure. The paper is now ready for processing.

It is probably wise to make a series of exposures using only a portion of the
8″ × 10″ paper. A mask can be used to allow four or more sets of exposures on
one sheet of 8″ × 10″ paper.

You should vary the red, green, and blue exposures in relation to each
other so that a number of combinations of exposure times might be covered.

Example:

	Red	Green	Blue
Exposure 1	−50%	N	N
Exposure 2	N	−50%	N
Exposure 3	N	N	−50%
Exposure 4	N	N	N
Exposure 5	+100%	N	N
Exposure 6	N	+100%	N
Exposure 7	N	N	+100%

N = Normal or recommended starting time.
This covers only a few of the combinations, others could be:

Exposure 8	−50%	−50%	N
Exposure 9	+100%	+100%	N

Etc.

You will have to make a series of tests and then decide the correction necessary. If all the tests are predominantly one hue, such as magenta, then you know that *all* the green exposures are too great.

Color cast	Remedy
Cyan	Reduce Red exposure
Magenta	Reduce Green exposure
Yellow	Reduce Blue exposure
Red	Reduce Green and Blue exposures
Green	Reduce Red and Blue exposures
Blue	Reduce Green and Red exposures

If all the pictures are too light in density, then all the exposure times will have to be increased. If all the pictures are too heavy in density (too dark), then all the exposure times will have to be decreased.

Making a Rough Exposure Check

The following can be used for white-light or tricolor exposure. For tricolor, make three individual exposures (one red, one green, and one blue of neutral areas if possible). For the white-light test, make a series of exposures on one piece of color paper. For both methods, open the lens one stop from your calculations. Expose the test and develop the Ektacolor 37 RC Paper in Kodak Dektol Developer, diluted 1:2, 68 F., 1½ minutes. Judge your results under white light. Look for equal density areas for each of the tricolor exposures. Estimate the change you will need to make so that the densities of the neutral-colored mid-density areas are the same in each of the three exposures. For white light, judge which step has the correct density.

Now expose a series of test prints or a series of exposures on one or more sheets of 8″ × 10″ paper. Don't forget to stop down one stop. Process in Ektaprint 300 solutions if using a drum processor, or Ektaprint 3 Chemistry if using a tank or tray.

Judge the color results under white light and estimate changes needed for your final print.

JUDGING THE COLOR PRINTS

Viewing Conditions

Your light source should meet the following requirements:
1. There should be at least 50 footcandles of intensity.

Starting with a negative of normal density, exposure in the enlarger can determine relative over- or underexposure of the final print (see below). Color rendition can be changed by varying filtration (see the following two pages).

Density Ring-A-Round

normal exposure

½ stop overexposed

½ stop underexposed

1 stop overexposed

1 stop underexposed

Filtration Ring-A-Round

CC-10 red change

CC-20 red change

CC-10 green change

CC-20 green change

CC-10 blue change

CC-20 blue change

Filtration Ring-A-Round

CC-10 cyan change

CC-20 cyan change

CC-10 magenta change

CC-20 magenta change

CC-10 yellow change

CC-20 yellow change

Landscapes, such as this view from the Garden of the Gods in Colorado, that have a high degree of color saturation and contrast have a most desirable impact. Slight variations in color balance would still render this print acceptable and probably would not be noticeable to the average viewer.

Historical landmarks are always favorite subjects. Color balance in this shot of the Capitol building in Colonial Williamsburg could vary from slightly yellowish to slightly reddish and be perfectly acceptable. The time of day governs the color balance.

Critical subjects, such as this white windmill, must be carefully printed. The windmill must be as nearly neutral as possible to be acceptable to the majority of viewers.

Children are highly popular subjects. The color balance here is acceptable, even though richly warm in hue (yellowish-red). Most acceptable skin tones are of warmish hues. The majority of viewers would reject blue- or green-tinted skin tones.

2. There should be a sufficiency of red, green, and blue light coming from the source. A 3200 K lamp provides such a sufficiency, but it and ordinary tungsten lamps are too yellow. A blue-coated bulb compensates for this yellowness by providing a color temperature of about 3800–4000 K.

Most ordinary fluorescent lamps are deficient in the red end of the visible spectrum. This causes red objects to appear darker than they should be. However, manufacturers have come out with fluorescent tubes that do have the increased amount of red light. These are:

> General Electric Deluxe Cool White
> Sylvania Electric Deluxe Cool White
> Westinghouse Electric Deluxe Cool White
> Macbeth Avlite Deluxe Cool White

You must realize that a color print will appear different under different types of illumination. For this reason, it is best to evaluate your prints under the *same illuminant* that will be used for the final viewing. This may be impossible, for you don't always know how a certain print will be viewed. This is why a standard viewing condition is suggested.

Viewing Prints. Let us assume now that the paper has been processed. (Processing will be covered in the next chapter.) By taking a critical look at your results, you must decide two things: (1) what is the proper exposure, and (2) must you make any change in filtration in the enlarger. If you find that the picture is way off color—if it is nowhere near the normal expectation—then you have to make an estimate of the correction you will need for the next test. There is a general rule to follow in making a filter change. If your print is off color, then add the color cast in the print to your original filter pack. If, for example, your print has a reddish cast to it, then add a CC-red filter to the pack that you used for printing the first print. The amount of red filtration depends on how red the test print is. The farther away from a normal print, the heaver the filter you need to add. The following chart tells you what type of filter to add for a few of the color casts that might be obtained.

Color Cast on Print	CC or CP Filter Correction to Make			
	Slight	Small	Moderate	Large
Red	05 Red	10 Red	20 Red	30 Red
Green	05 Green	10 Green	20 Green	30 Green
Blue	05 Blue	10 Blue	20 Blue	30 Blue
Cyan	05 Cyan	10 Cyan	20 Cyan	30 Cyan
Magenta	05 Magenta	10 Magenta	20 Magenta	30 Magenta
Yellow	05 Yellow	10 Yellow	20 Yellow	30 Yellow

The following example will help you work out a filter problem. Filters in enlarger when test print was made: 50R + 10Y. The test print is moderately too green—the table says add 20G filter to the original pack.

First you should change the filters to their subtractive components.

$$50R + 10Y = 50M + 50Y + 10Y$$
$$20G \quad\quad = 20C + 20Y$$

Add $\quad\quad\quad\quad 20C + 50M + 80Y$ (like filters combined)
Subtract $\quad\quad -20 \quad\;\; -20 \quad\; -20$
neutral density*

$$30M + 60Y = (30M + 30Y + 30Y)$$

Combine to fewest number of filters: 30R + 30Y

You would then change the filter pack to the 30R + 30Y, remove the negative, adjust the level of intensity, replace the negative, and give the exposure time that produced the correct density.

Methods for Estimating the Color Filters

Look at the print under the standard source through CC filters until the mid-density areas look correct to you. A print having a large color cast cannot be judged very accurately. You should try to get a print within a 20 CC (at the maximum) range before you try visual judging.

There are two ways to hold the filters. One is to hold them away from the print so that light from the source does not go through the filter and fall on the print. The other is to lay the filter directly on the mid-density area of the print. The former case takes twice the density of filter to make the same corrections as the latter.

To the determine the filters to use: With the first method, add half the complement of the viewing filters. (Half strength is used because the contrast of the print material is fairly high, and the filter produces a greater change in color

*That is, subtract the equivalent, overlapping filtration of C, M, and Y.

balance than might be expected.) If you lay filters on the print, use the complement of the viewing filters.

Example:

(1) Viewing filters	20R + 10Y	
(2) Half the complements	10C + 05B	
(3) Original filter pack	50R + 10Y	
(4) Changing (3) to sub-tractive components	50M + 50Y + 10Y	
(5) Changing (2) to sub-tractive components	10C + 05C + 05M	

Adding lines (4) and (5) 15C + 55M + 60Y (like filters combine)
Removing 15 neutral density −15 −15 −15

(6) Result = —— 40M + 45Y = 40M + 40Y + 05Y

Fewest number of filters (6) = 40R + 05Y

New filter pack is 40R plus 05Y plus the 2B filter and the heat-absorbing glass (which you use in all cases).

Another method for estimating the filter correction is to lay filters on a white sheet of paper alongside the color print. Keep changing or adding filters until you feel that the color of the filters matches the color cast of the print. Now *add* these filters to the original pack.

You might find as you work with the process that you get different results from your viewing than those given above. So much the better. All of us view things differently (thank goodness), so you shouldn't be surprised if you find that using half the complement does not give you enough correction. At this point, you should change your technique of evaluating your results when viewing test prints.

Adjusting Your Exposure

1. You can now put the new filter pack in your enlarger, adjust the intensity of the illumination using a photometer, and give the exposure time found to be best in your test print.

2. You can put the new filters in the enlarger and compute the exposure time using a filter factor as below:

FACTORS FOR KODAK CC AND CP FILTERS

Filter	Factor	Filter	Factor	Filter	Factor
025M	1.1	025Y	1.1	025R	1.1
05M	1.2	05Y	1.1	05R	1.2
10M	1.3	10Y	1.1	10R	1.3
20M	1.5	20Y	1.1	20R	1.5
30M	1.7	30Y	1.1	30R	1.7
40M	1.9	40Y	1.1	40R	1.9
50M	2.1	50Y	1.1	50R	2.2

If more than one filter is involved, multiply the factors together. Directions: Divide the old exposure time by the computed or listed factor for any filter(s) changed (removed) in the pack. Then multiply your answer by the factor for any filter or filters added.

Example:

	Filter in enlarger	Time
	50R + 10Y	10 seconds
New filter pack:	40R + 05Y	?

(50R)2.2 × (10Y)1.1 = 2.4
Divide 10 seconds by 2.4 = 4.1
(40R)1.9 × (05Y)1.1 = 2.1
Multiply 4.1 × 2.1 = 8.6 or 8½ seconds (new time)

Color Cast on Print	Add	or	Subtract
Cyan	Cyan filter		Red filter (M + Y)
Magenta	Magenta filter		Green filter (C + Y)
Yellow	Yellow filter		Blue filter (C + M)
Red	Red filter (M + Y)		Cyan filter
Green	Green filter (C + Y)		Magenta filter
Blue	Blue filter (C + M)		Yellow filter

Why would you add a color filter or subract its complement to correct the color cast on a print? Suppose we have a print that is too green. Why is it too green? Mainly because there is too much cyan and yellow dye produced by too much red- and blue-light exposure. To make a better print, we have to reduce this red and blue exposure. This is done by adding a green filter. The green filter absorbs red and blue light, thus reducing the green cast on the print.

We can also correct by subtracting a magenta filter from the pack (provided we have a magenta filter in the pack). Since the magenta filter absorbs green light, its removal permits more green light to reach the color paper, forming more magenta dye and neutralizing the green cast. The print may become slightly too dark, but we can compensate for this by reducing the overall exposure.

SUMMARY

Try to use the fewest number of filters over the lens when printing, because the more filters, the poorer the image quality of the print. Also try to eliminate all neutral density, which only increases the exposure.

After exposing the color paper, try to standardize the time interval between exposure and processing. The latent image starts to change immediately after exposure and seems to stabilize somewhat after four hours. If you can't maintain the same time interval, wait the four hours for processing so that your results will be more consistent. If you find you cannot process on the same day you made the exposure, then freeze the exposed paper at 0 F.

TIPS

1. Allow paper to come to room temperature before using.
2. Don't move enlarger or easel during tricolor exposures.
3. Use the 2B and heat-absorbing glass when exposing with white light.
4. Handle the paper with care. Don't touch the emulsion.
5. Identify the prints by writing lightly on the back with a grease pencil.
6. Handle the CC or CP filters with care.
7. Only remove the amount of paper you intend to expose. Keep the rest in the special vapor-barrier bag. Keep the bag end rolled up.
8. Use a voltage regulator if the power supply is inadequate.
9. Mask off all stray light from around the negative in the negative carrier.
10. Consult the Ektacolor 37 RC Paper instruction sheet for starting points for filtration with various Kodak color negatives.
11. You can contact print the negatives onto Ektacolor 37 RC Paper using a print frame and the enlarger as a light source. Reduce the exposure time 10% from that used for enlarged images.

5

PROCESSING EKTACOLOR 37 RC PAPER

Ektacolor 37 RC Paper is designed to be processed in Ektaprint chemicals. The paper can be processed in trays or processing baskets and tanks using Ektaprint 3 Chemicals, or on a Kodak Rapid Processor Model 11, 16-K, or 30 using Ektaprint 300 Developer and Ektaprint 3 Chemistry for the rest of the steps.

The processing is not difficult; simply follow directions to achieve high-quality results.

KODAK EKTAPRINT 3 PROCESS

The chemicals required for each of the solutions are supplied in prepared form in 1-gallon and 3½-gallon sizes as follows:

Kodak Ektaprint 300 Developer
Kodak Ektaprint 3 Developer
Kodak Ektaprint 3 Bleach-fix and Replenisher
Kodak Ektaprint 3 Stabilizer and Replenisher

For processing Ektacolor 37 RC Paper you will need to set up either a tank or tray system, or a drum.

You must take precautions in mixing these chemicals. I recommend that you use clean rubber gloves when working with these chemicals and solutions. You should make sure that all mixing containers and the area that you work in are free from any spilled chemicals, powder, or solutions. Since some of the solutions have toxic vapors, you should do your mixing in well-ventilated areas. Also all storage containers should be tightly covered when not in use. Similarly, tanks should be kept covered when not in use. The following directions are for mixing 1-gallon Ektaprint. Follow the instructions carefully when mixing these solutions and avoid contamination (carrying over solutions from one step to another). Any contamination will seriously impair print quality. Take special

care to avoid even the slightest contamination of the developer with the bleach-fix during mixing and processing. The stabilizer also has a very deleterious effect on the developer. Mixing of chemicals in printing and processing areas should be avoided, because the chemicals may cause spots on the prints.

Storage of Solutions

For best results, do not use solutions that have been stored longer than the following times:

Solution	Storage Tank, Floating Lid	Full, Stoppered Glass Bottles
Developer (unused)	6 weeks	6 weeks
Developer (partially used, unreplenished)	1 week	2 weeks
Developer Replenisher	6 weeks	6 weeks
Bleach-Fix	8 weeks	8 weeks
Stabilizer	8 weeks	Indefinite
C-22 Stop Bath	8 weeks	8 weeks

Mixing the Developer

The following instructions are typical. You should always consult the instructions supplied with each batch of chemicals to make sure that you are following the latest recommendations.

Start with 3 gallons of water (80–90 F). Shake the small bottle marked A and pour its contents slowly and carefully into the water, stirring until the solution is uniform. While stirring, add the contents of the bottle marked B and stir until the solution clears. With adequate ventilation, add the contents of the bottle, part C. Then add sufficient water to bring the total volume to 3½ gallons and stir until the solution is uniform. When mixed the solution appears somewhat hazy, but this is normal. Be careful this solution does not spill onto your skin.

Mixing the Bleach-Fix

Start with 3 gallons of water at 80–90 F. Add the contents of part A while stirring constantly. Then add the contents of part B, again while stirring constantly. Add water to bring the total volume to 3½ gallons and stir until uniform.

Mixing the Stabilizer

Add the stabilizer concentrate slowly to 3½ gallons of water (70–75 F) while stirring rapidly.

THE REACTIONS THAT OCCUR IN COLOR PROCESSING

The Developer

In the developer, the exposed silver halides are reduced to metallic silver, and the developer itself is oxidized. The oxidation products that are given off during this reaction interact with the color couplers found in the various layers of the color paper. These color couplers change to their respective dyes, that is, cyan, magenta, and yellow. At a given processing time at a given temperature, all three dye images come into balance. This means that when you print the color negative, if you have whites, grays, and blacks, they will print as whites, grays, and blacks (not as whites, blue-grays, and yellowish-blacks).

The Bleach-Fix

Development is stopped in the bleach-fix, and the metallic silver formed by the color developer in the three layers changes to a soluble silver salt that is easily washed out.

The Washes

You must make sure that the washes called for in the processing outline are doing the job that they were intended to do. This job is mainly to remove the previous chemicals. In order to do this, the washes should be fairly vigorous if you are processing in tanks. You need at least a 2-gallon change of water per minute. If you don't wash the prints thoroughly at the proper processing point, you can expect scum and stains on your prints and probably poor keeping quality in the long run. With drum processors, the washing schedule should be followed precisely.

The Stabilizer

The stabilizer is designed to increase the permanence of the dyes when the print is dry. You should not wash your prints following this last step. Instead, dry them with the stabilizer and stabilizing additive right in the emulsions.

PROCESSING EKTACOLOR 37 RC PAPER IN A TANK

Probably the easiest way for an advanced amateur or professional to proc-ess his color paper is in a system of tanks in a water jacket. A series of 1-gallon size 8″ × 10″ tanks can accommodate any size print up to 8″ × 10″; 4″ × 5″ prints can easily be processed in multiple hangers. The 8″ × 10″ prints are most easily processed in basket hangers, as described in the equipment chapter. The ad-vantage of this water jacket/tank system is that the solutions can easily be kept to their required temperatures in processing. The water jacket generally is used for the washes, and therefore you should have an adequate supply of water moving through the water jacket at all times. This method is more expensive than the tray method, which will be described later in the chapter, but if you have numerous prints to process, this is the easiest way to do it. It is particu-larly important that you have a repeatable system of agitation of the hangers in the processing tanks. In a tank setup, a minimum of three tanks is necessary in order do the dark stages of processing without dumping any solutions. It is, however, much more convenient if you have the five tanks comprising the entire processing procedure.

Preparation for Processing

Make sure that the stainless steel tanks are perfectly clean before pouring the solutions into them. In getting the processing line ready, set up the so-lutions from left to right starting with the color developer. Pour each solution carefully into the tank so you do not splash and contaminate any other solution. Maintain a level of about one inch below the top edge of the tank (fig. 5-1). This is to allow you room enough to pick up the hangers during agitation *without* getting your hands into the solution. If you know your skin is sensitive to any solution, use rubber gloves.

Space the tanks that are needed during the dark stage of processing so that there are about three inches or so between tanks. You should try to orient yourself in the dark so that you get the feel of loading the hangers, placing them in the proper tanks, and agitating them properly as will be described shortly. You should be *quite* sure of yourself in the dark so you do not make the mistake of placing the hangers in the wrong solution. Check the temperatures of your processing solutions to see that they are within the proper tolerance recom-mended by the manufacturer. If your processing setup allows it, have an extra hose of running water—this is useful to rinse the tops of the hangers during the wash steps. Always guard against contamination. The better the precautions taken the better the results.

Locate your hangers in a convenient place so that when the lights are out, you will have no trouble finding them; also have your exposed paper in a convenient place. It is helpful to have some place to put the loaded hangers so that they do not become mixed up with the empty hangers or accidentally dropped and lost on the floor. Now set your processing timer for eight minutes.

Fig. 5-1. An 8″ × 10″ tank processing setup. Space the tanks so you minimize the chance of splashing solutions from one tank to another. Picture shows basket hanger being used for processing of paper. Thermostat mixing valve is at top right of picture.

If you have a luminous timer, charge up the luminous dial so that it will be easily visible in the dark.

Turn off the room lights. I prefer to work in total darkness for the dark stages of the processing, but if you do not, use a No. 10 Wratten safelight filter with a 15-watt lamp at a distance of 4 feet or greater. The total exposure for any one piece of paper should not be more than 4 minutes. Now if you are using the plastic screening type basket hangers, take out two sheets of paper and put

them in, back to back. Hold them by the lower edges and feed these lower edges, both sheets together, into the channel and between the two edges of the plastic screen. Then grasping the top center of the papers, gently push the two sheets all the way down into the basket hanger. A little practice may be required. Once you have done it a few times, it becomes an easy matter to load the paper. Load only the number of hangers you can process in the tank at any one time. The hangers should be inserted into the solutions at the same time so that each piece of paper is given the same amount of development.

CARRYING OUT THE PROCESSING

Step 1. *Color Developer* (88 F ± ½ F)—3½ minutes. Lower the hangers into the solution and start the timer. You should lift the hangers up and down for the first 30 seconds. Do not lift the hangers all the way out of the solution, but rather just about 2 inches out. A complete cycle of up and down should take about 1 second. Every 15 seconds agitate the hangers by this up-and-down method for a period of 5 seconds; try to do it using the same technique each time. If you want to maintain consistent results, your agitation must be fairly consistent. Thirty seconds before the end of the 3½-minute developing time, lift the hangers and drain them from one corner. At the end of the processing time place the hangers into the bleach-fix.

Step 2. *Bleach-Fix Bath* (88 F ± 2 F)—1½ minutes. Agitate the hangers with the same up-and-down motion for the first 30 seconds after entering the solution, and thereafter 5 seconds every 15 seconds. Thirty seconds before the end of the processing time, lift the hangers and drain from one corner. Place the hangers in a running water wash for 2 minutes.

The room lights may now be turned on. Carry out the remaining steps under normal illumination.

Step 3. *Wash* (88 F ± 2 F)—2 minutes. Make sure you have a vigorous flow of water at this point. The wash water temperature may be in the range of 86–90 F, although if you are working with a water jacket system, you will probably have all of your temperatures, including the washes, at 88 F. Thirty seconds before the end of the wash time, lift the hangers, drain them from one corner, and place them in the stabilizer bath.

Step 4. *Stabilizer* (88 F ± 2 F)—1 minute. Agitate for the first 30 seconds after entering the stabilizer, and 5 seconds every 15 seconds thereafter. Thirty seconds before the end of the time period, lift and drain the hangers from one corner. Then remove the processed sheets from the hanger and place them face up in a tray of buffer solution. With a clean film sponge, sponge the surface of each print carefully. The prints may be squeegeed, but care must be taken to avoid abrasion of the emulsion side.

Step 5. *Drying.* Drain the prints and place them face up on blotters or on plastic window-screen racks. You can hang them clipped with spring-type clothespins, two prints together, back to back on a line. Clip all four corners.

Forced air will hasten the drying. Temperature should not exceed 225 F. *The prints cannot be hot or cold ferrotyped.*

In all of the above processing steps, the drain time is part of the total processing time. If the processing equipment has good solution-drain characteristics, the drain time can be reduced to 20 seconds, but the total processing time for each step should remain unchanged.

If trouble with streaks is experienced, a 1-minute C-22 stop-fix step may be inserted ahead of the wash prior to the bleach-fix (after the development has been completed). The usual drain time of 30 seconds (or 20 seconds if you choose) is to be included in this step. An additional wash step in running water for 1 minute is required after this stop-fix and before the print hangers are transferred to the bleach-fix.

PROCESSING THE COLOR PAPER IN A TRAY

You can successfully do tray processing with a minimum of three trays. The trays should be slightly larger than the paper you will process. In selecting trays, almost any type will do as long as they are clean. Enameled trays must not have any chipped areas. The solutions will react with the exposed iron and produce red-colored spots on the prints.

Organize the trays and solutions so that everything you need is handy and in the proper order. Clean out the three trays and empty the chemicals into them. The developer should go into the first tray at the left and the bleach-fix bath in the second tray. The third tray will be used for the running water wash. The solutions should be at the correct temperature before you start processing—use a water bath to maintain the temperature.

Use only enough solution to process the exposed sheets. One quart of solution in an 8″ × 10″ tray is recommended for processing three 8″ × 10″ sheets of paper. Because of the large air surface area of the trays, the solutions must be thrown away at the end of each processing. Therefore, you should use only enough solution to process the exposed paper—you wouldn't want to use a gallon of solution to process one or two sheets. The other extreme should be avoided too; that is, using too small an amount of solution for the paper being processed. A quart of solution can process six sheets of Ektacolor 37 RC Paper, but you normally will do only three in this amount of solution.

Handling paper with rubber gloves can be quite an experience for the inexperienced worker. The paper is quite slippery when wet and often adheres to the bottom of the tray, making agitation difficult.

You will find the use of the recommended No. 10 safelight quite a convenience in tray processing. Make sure that the safelight is safe; that is, at the proper distance and of the correct brightness.

Set timer for 8 minutes. *Turn off the white lights.*

Step 1. *Color Development* (88 F ± ½ F)—3½ minutes. Hold the paper with one hand and insert it into the developer emulsion side down, one sheet at

a time. Have a corner cut off the first sheet (lead print) so you can identify which was the first.

The paper should be immersed quickly and evenly. I find that by holding the paper by one end and putting it in the developer face down with a kind of sweeping motion, you can obtain even development. Immerse all the sheets, one after the other, as quickly as possible, but don't let haste make waste. If you get too excited trying to get the paper in quickly and everything gets balled up, then slow down. Try to maintain equal intervals of 20 seconds between the immersion of sheets. Push the prints to the bottom of the tray to allow room for the following print. You might find that the sheets of paper will stick to each other during the first part of the development. The only remedy is to separate them physically. Determine why the prints stick together. Perhaps you aren't using enough solution. Maybe the one print isn't getting "wet" enough before the next print is put into the developer. It may also be your technique of handling the paper.

Turn off the safelight once the prints are in the developer. If necessary, the safelight may be turned on if you are having trouble with the prints. However, don't leave the safelight on for the entire processing time.

When all the prints are in the developer, emulsion side down, continue to interleave them by pulling the bottom sheet out and placing it on top of the stack. Keep the emulsions face down. The lead print should be at the bottom of the pile when the cycle is complete. You can determine which one is the lead print by its cut corner. Twenty seconds before the end of the developing time remove the first sheet and drain for 20 seconds. Then immerse it in the bleach-fix solution. Transfer the other two sheets in the same manner at 20-second intervals. Repeat this procedure in each of the other processing steps.

Step 2. *Bleach-Fix Bath* (88 F ± 2 F)—1½ minutes. Place the lead print in the bleach-fix. Agitate it with one hand to make sure the emulsion has been covered with solution. At this point you will have to keep one hand in the developer and one hand in the bleach-fix.

At 20-second intervals, with one hand pull out prints from the bottom of the stack in the developer and pass them to your other hand. Place them in the stop bath on top of the lead print, emulsion sides face down. Continue to agitate by interleaving the prints.

Step 3. *Wash* (88 F ± 2 F)—2 minutes. As soon as the prints have been placed in the running water *turn on the white lights.*

Dump the developer and bleach-fix from their trays and rinse out one tray. Place the stabilizer solution in it. Continue to interleave the prints in the wash periodically.

Step 4. *Stabilizer* (88 F ± 2 F)—1 minute. Maintain continuous agitation.

Step 5. *Dry* (not over 225 F). At the end of the stabilizer processing time, drain the print and lay it face up on a clean surface or drying screen. Take a clean film sponge, dip it in the stabilizer, squeeze it out, and sponge off the surface of the print. Prints may be hung to dry on a line using spring clothespins on *each* corner. Dry two prints back to back. Ektacolor 37 RC Paper cannot be ferrotyped either with or without heat.

Large-Size Prints

If you intend to make large-size prints, you should first make a small test print of an important area of the subject. Take one large sheet and cut it into small pieces, though no smaller than 8″ × 10″. Process this test or tests, then judge for corrections before proceeding with the large print.

When processing only one print in a tray, use the tilt-tray type of agitation. With the emulsion side of the print up in the tray, raise and lower the front of the tray; raise and lower the left side; raise and lower the front again; raise and lower the right side. Repeat this cycle continuously. Include the usual 20-second drain time with each step.

TIPS FOR BETTER PROCESSING

1. Mix the chemicals according to the manufacturer's instructions.
2. When mixing, make sure the first chemical is dissolved before adding the next.
3. Store mixed chemicals at room temperature. Cold temperatures may cause some solutions to precipitate out.
4. Store solutions in tightly stoppered bottles or in tanks that have floating lids.
5. Do not store the bleach overnight in stainless steel tanks.
6. Keep a careful record of the paper processed through a solution, for in tank processing the time increases with increased use.
7. Do not wash the prints after processing, for this removes the stabilizer, thereby removing the protection for the dye images.
8. If you are processing in a tray, using a larger tray for a water bath, or in a sink with standing water, be careful not to flood the tray with water when you agitate the paper.

FAULTS DUE TO PROCESSING OR PRINTING

Slightly Contrasty. Overdevelopment due to too long a processing time, too warm solutions, or too much agitation. Print would also have hue shifts due to overdevelopment.

Lower Contrast. Underdevelopment due to too short development time, too cold solutions, or not enough agitation. Print could also have hue shifts due to underdevelopment.

Red Spots. Iron contamination in water.

Streaks and Mottle. Poor agitation, uneven development.

Yellow or Orange Stain. White-light fog. Could be due to light leaks in darkroom or enlarger.

Cyan Fog. Safelight fog. Do not overdo the use of the safelight. Red light will also cause this.

White Spots. Dust on negative or in optical system.

Cyan Color Balance. Developer contaminated with bleach-fix.

Mounting Color Prints

You can use dry-mounting tissue to fasten the color prints to a mount board. There are two precautions to take:

1. Heat the blotter or cardboard you use over the prints so that all the moisture is driven out. If you don't do this, the blotter is liable to stick to the surface of the print.

2. The temperature of the mount press should be in the range of 210–230 F. Use a temperature no higher than that needed to bond the print to the mount.

IMPORTANT SUPPLEMENTARY INFORMATION CONCERNING BATCH PROCESSING WITH KODAK EKTAPRINT 3 CHEMICALS

In batch processing, and particularly in machines that transport paper in baskets automatically, prints may show screen patterns or cyan streaks. If the processing equipment permits, such difficulties can be minimized by care in giving the initial 30-second hand agitation *that is recommended in the batch processing instruction sheet.* The two most important times to give this agitation are in the developer and the bleach. The recommended technique is a *rapid up-and-down movement of about two inches,* with as much movement toward the sides and ends of the tanks as can be managed. Although the paper should not be removed from the solution, the agitation should definitely be vigorous. The cover should be on the basket to prevent the sheets of paper from floating upward.

To prevent carrying over excessive amounts of developer into the bleach-fix, the drain time between solutions must never be less than the recommended 20 seconds. If possible, the drain time should be extended to 30 seconds for baskets of complex design.

If processing nonuniformity persists, it can usually be eliminated by a 1-minute treatment in a working solution of Kodak Stop Bath and Replenisher, Process C-22, between the developer and the bleach-fix. The process then becomes one requiring four solutions.

SUMMARY OF STEPS FOR TRAY AND BASKET PROCESSES

Processing Step	Remarks	Temp C	Temp F	Time in Minutes*	Time at End of Step (w/optional steps)
1. Developer	No. 10 or No. 13 Safelight Filter	31 ± 0.3	88 ± ½	3½	3½
(Optional steps)†					
a. C-22 Stop Bath	Agitate as described	31 ± 1.2	88 ± 2	1	(4½)
b. Wash	Running water	31 ± 1.2	88 ± 2	1	(5½)
2. Bleach-Fix		31 ± 1.2	88 ± 2	1½	5 (7)
	Remaining steps can be done in normal room light				
3. Wash	Running water	31 ± 1.2	88 ± 2	2	7 (9)
4. Stabilizer	No rinse after this step	31 ± 1.2	88 ± 2	1	8 (10)
5. Dry	Air dry—don't ferrotype!	Not over 107	Not over 225	—	— —

*Include a 20-second drain time in each process step. Baskets of complex design can be drained for 30 seconds to prevent excessive carry-over.
†Optional steps are suggested if marks or streaks are observed on the surface of prints. Excessive developer carry-over and inadequate agitation are usually responsible for such marks.

PRINT FINISHING

1. *Spotting:* White specks and spots on the prints, caused by dust on the negative, can be spotted in the conventional manner by using any of the commercially available spotting colors, such as Flexichrome Spotting Colors.

2. *Dry Mounting:* Prints can be dry-mounted with Fotoflat tissue, manufactured by Seals, Inc. The temperature of the dry-mounting press or iron should not exceed 230 F. Tissues that melt at higher temperatures (usually 225 F) should not be used.

3. *Matte Finishing:* A dead-matte finish can be imparted to the prints by using one of the commercially available matte-finish sprays, such as Getzol.

DRUM PROCESSING

For the greatest convenience in processing Ektacolor 37 RC Paper, you can use a Kodak Model 11 or 16-K Rapid Color Processor (see fig. 5-2). This type of drum processor allows you to process a print in five minutes and uses three solutions (Ektaprint 300 Developer) at 100 F.

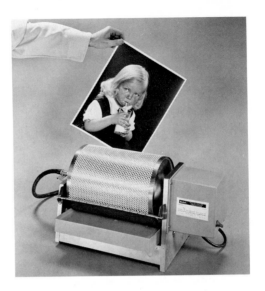

Fig. 5-2. Kodak Model 11 Rapid Color Processor for process-
ing Ektacolor 37 RC Paper in 5 minutes total time. Requiring
special solutions and constant 100 F temperature, it is quick
and produces consistent results.

Advantages for the Amateur

 1. Five minutes time on the processor.
 2. Only 4 minutes in the dark.
 3. Consistency in processing.
 4. Solutions are used at room temperature.

Disadvantages for the Amateur

 1. The processor requires a 100 F supply of hot water.
 2. The initial cost is high.

Recommendations for Using the Drum Processor

A. Preparation:
 1. Provide yourself with a set of three plastic cups with about a 4- to 6-ounce capacity. Mark the 4-ounce level on each. Identify each cup for one of the three Ektaprint solutions.
 2. Set the Model 11 Processor on the top of an upside down 11″ × 14″ tray. Level the processor, using a level on the top of the drum. Adjust the feet until the bubble in the level is between the marks.
 3. Adjust the solution tray so the drum just clears at all points. This indicates that the tray is level also. Test by pouring 4 ounces of water into the center of the tray while the drum is running. Observe the surface of the drum

carefully to insure that it is evenly wet all over. If the drum is wet on only one end, the tray needs further adjustment.

4. The processor power cord must be plugged into a grounded outlet.

5. Mix the Ektaprint solutions (Ektaprint 300 Developer) according to instructions.

B. Preliminary steps:

1. Clean the drum once every 20 hours of operation by wiping with a wet sponge and Bon Ami or a powder type of cleaner. Rinse clean. Before each use, rinse the drum and tray with clean water.

2. Have water at 100 F running through a plastic wand into the processor drum. The flow should be about ½ gallon or slightly more per minute.

3. Allow the overflow of water from the drum to flow into an 11″ × 14″ tray. This can be used as the prewet tray.

4. Obtain a timer with a luminous dial, such as the Gra-Lab timer. Set it so that it will run *continuously.*

5. Measure out 4 ounces of each solution into the plastic cups or whatever measures you require. I find it convenient to have an 11″ × 14″ tray upside down to the left of the processor. Place the cups in the order of use: (1) developer, (2) bleach-fix, and (3) stabilizer. If you separate solutions 1 and 2 from the rest by placing them at the front of the tray, there is less chance of getting confused and using the wrong solution in the dark. Solutions 1 and 2 are used in the dark, and 3 is used in the light.

6. Use a Wratten No. 10 safelight filter during the dark stage of processing. Do not use a lamp stronger than 15 watts behind the safelight filter and place it no closer than 6 feet from the processor. Use two safelights if possible: one over the processor and one to the left of the processor, near the solutions.

7. Wash the blanket thoroughly prior to each use. Place it in an empty tray with the lugs on the bar facing up. Now turn the bar under one-half turn so that the netting is over the top of the bar. This is the position the bar and blanket should be in when you place the print on the blanket.

C. Processing exposed color paper:

1. Pour the developer into the processor tray with a sweeping motion so that it is distributed evenly over the entire tray. Use this motion each time you add a solution.

2. Turn out the white light.

3. Take your exposed color paper from the lighttight storage container. Place it emulsion side up in the prewet tray and start the drum revolving by turning on the switch. Agitate it continuously. After the print has been in the water for 30 seconds, lift the print, emulsion side toward you, by grasping the center of the narrow side of the paper. With your left hand hold the bar in the center. Remember the bar has been turned one-half turn away from you so that the lugs face away from you. Now bring the center of the top of the paper to the center of the bar. Slide your left hand over so that you can grasp the left edge of the print and the bar. Slide your right hand so that you can grasp the right edge of the print and the bar. Keep the top edge of the paper just below the top edge of the blanket. *Check your timer.* At some convenient reference point on the

clock or timer, 0, for example, bring the paper and blanket in contact with the back of the drum and bring the blanket and print over the top of the drum to the point where you can insert the bar of the blanket in the two catches on either side at the front of the processor. (It is a good idea to practice using the drum first with water and an old print.)

4. Develop for 2 minutes. Five seconds prior to the end of the time, dump the tray by lifting the front edge.

5. Take the plastic wand out of the drum and run water on the back of the print for 25 seconds. Meanwhile, rinse the tray and dump it several times. Finally, dump the tray and drain it for 5 seconds.

6. Pour the bleach-fix into the tray. Time for 1 minute. Drain the last 5 seconds of each processing time. *Turn on the white light.*

7. Rinse 25 seconds; drain 5 seconds. (See step 5.)

8. Add the stabilizer. Process for 30 seconds. Drain. *Turn off the processor.*

9. Remove the blanket and the print. Dry the print.

10. Rinse off the processor and the tray thoroughly. Carefully wash the blanket in preparation for processing the next print.

Always be on guard for contamination. Make absolutely sure the cups, processor, and blanket are clean before use.

SUMMARY OF STEPS FOR KODAK RAPID COLOR PROCESSOR, MODELS 11 AND 16-K

Processing Step	Remarks	Drum Temperature		Time in Minutes*	Time at End of Step
		C	F		
1. Prewet	In tray of water	21–39	70–102	½	½
2. Developer	Kodak Safelight Filter No. 10 or No. 13 for first four steps	37.8 ± 0.3	100 ± ½	2	2½
3. Wash	Running water	37.8 ± 1	100 ± 2	½	3
4. Bleach-Fix		37.8 ± 1	100 ± 2	1	4
Remaining steps can be done in normal room light					
5. Wash	Running water	37.8 ± 1	100 ± 2	½	4½
6. Stabilizer	No rinse or wash after this step	37.8 ± 1	100 ± 2	½	5
7. Dry	Air dry—don't ferrotype!	Not over 107	Not over 225	—	—

*Include drain time of 10 seconds for prewet step; 5 seconds for all other steps.

Caution: Observe chemical caution notices given on containers and in instructions.

6

OTHER COLOR PROCESSES

AGFACOLOR PROCESS

Characteristics

The Agfacolor negative films are different from the Kodak color negatives in that they have a more or less clear base (no colored masks). This allows the subject to appear in the complementary colors you would normally expect to find. The films are integral tripacks producing the final image in terms of cyan, magenta, and yellow dye.

Agfacolor negative film is available in the CNS type. The CNS film has an exposure index of 80 and is available in 35mm, 20 exposures, size 120 roll film, and size 126 cartridges. The CNS films may be exposed under daylight or tungsten light without the use of correction filters. All color balance correction is done at the printing stage.

The CNS films are processed in Agfacolor Film Developer S. All Agfacolor films, Agfacolor paper, and Agfacolor chemicals are available from Agfacolor dealers.

PROCESSING AGFACOLOR FILM

Mixing the Solutions

Warning: Persons with sensitive skin should take precautions when mixing the color developer. Avoid direct contact with the color developer wherever possible. If you do touch the developer, rinse hands in 1 per cent acetic acid and then wash thoroughly. Use the soap solutions described in Chapter 3. Rubber gloves must be kept clean, and the inside of the gloves *must* also be kept dry.

1. *Agfacolor Film Developer S (NPS I)*—1-liter (34 oz) size. This developer is to be mixed in two parts, A and B. Part A contains three packages of chemicals, two marked A1 and the third marked A2.

In 200 ml* (7 oz) of water at 85–105 F, add both bags marked A1 while stirring. When the chemical is entirely dissolved, add part A2 and stir until dissolved. This mixture is designated part A.

In 600 ml (20 oz) of water at 85–105 F dissolve the chemical marked part B. Stir until thoroughly mixed. This solution is designated part B.

Now add solution A slowly to solution B while stirring. Avoid mixing or stirring any air into the solution. Rinse mixing container A with clear water, and pour the water into solution B until you have a total of 1 liter (34 oz) of solution (slightly more than one quart).

Store the mixed developer in a brown, tightly stoppered bottle. LET STAND FOR 12 HOURS BEFORE USING.

2. *3% Magnesium Sulfate.* † Weigh out 30 grams (slightly more than one ounce) of magnesium sulfate (Epsom Salts) and dissolve in 800 ml (25 oz) of water at 75–85 F. If you are not able to weigh out the Epsom Salts, use two level teaspoons full as a crude substitute measure. After solution is thoroughly dissolved, add water to make 1 liter (34 oz) of solution. To the liter of solution add 30 ml (1 oz) of Color Developer S.

3. *Agfacolor Bleach (N II).* In one liter (34 oz) of water at 75–85 F add the contents of the package marked Agfacolor Bleach. Stir until entirely dissolved.

4. *Agfacolor Fixing Bath (N III).* In one liter (34 oz) of water at 85–105 F add the contents of the package marked Agfacolor Fixing Bath. Stir until entirely dissolved.

All solutions are ready to use after mixing except the developer, which must stand 12 hours before use.

Capacity of the Solutions (1 liter size)

Solutions	Capacity in rolls
Agfacolor Develop S (NPS I)	10-35mm (20 exp.); 6-120
Agfacolor Bleach (N II)	10-120
Agfacolor Fixing Bath (N III)	6-135; 6-120

* A ml (milliliter) is approximately equivalent to a cc (cubic centimeter). There are approximately 30 ml in a fluid ounce.

† Agfa now supplies 1-liter kits with a new solution, *Agfacolor Intermediate Bath (NZW)*, for use instead of the 3% magnesium sulfate (Epsom Salts) that user has to mix. Other kits remain unchanged, but NZW is generally available. It will process 6 rolls of 120 film and lasts 3 months. The user must add the same 30 ml of Color Developer S per liter of solution that he would with the 3% magnesium sulfate.

Life of Solutions

Unused Color Developer S	— 6 weeks
Used Color Developer S	— only a few days
3% Magnesium Sulfate	— 6 weeks
Bleach and Fixer	— 3 months

Processing

Load the film into your processing tank in complete darkness. When the film is "safe" turn on white lights.

Step 1. *Agfacolor Film Developer S (NPS I)* 68 F ± ½ F)—8 minutes. Pour in solution, agitate for the first 15 seconds, and thereafter once every 30 seconds. Also tip tank upside down if you are able every 30 seconds. Include your drain time at end of development step as part of processing time.

Step 2. *3% Magnesium Sulfate* (67-69 F)—2 minutes.* Since this is still part of the development process, keep tank tightly closed. Agitate for the first 15 seconds and thereafter every 30 seconds.

In all the following steps, drain the film for the last 10-15 seconds of the processing time.

Step 3. *Wash* (running water 57-68 F)—15 minutes. Dump the water in your wash tank once a minute.

Step 4. *Agfacolor Bleach (N II)* (68 ± 1 F)—5 minutes. Agitate for the first 15 seconds in the bleach and thereafter 5 seconds every 30 seconds.

Step 5. *Wash* (running water 57-68 F)—5 minutes. Dump the water in your wash tank once a minute.

Step 6. *Agfacolor Fixer (N III)* (64-68 F)—5 minutes. Agitate for the first 15 seconds in the fixer and thereafter 5 seconds every 30 seconds.

Step 7. *Final Wash* (running water 57-68 F)—10 minutes. Dump the water in your wash tank every two minutes. Sponge off film under water.

Step 8. *Wetting Agent* (64-68 F)—1 minute. Use a fresh bath of wetting agent for each process.

Step 9. *Dry.* Hang in dust-free atmosphere *without* further rinsing or wiping.

* For Agfacolor Intermediate Bath NZW use at 68 F ± ½ F, 4 minutes.

SUMMARY OF STEPS FOR PROCESSING
AGFACOLOR NEGATIVE FILMS

	Processing Time in Minutes	Temperature (F)
1. Agfacolor Film Developer S	8*	68 ± ½
2. 3% Magnesium Sulfate†	2	67-69
3. Wash	15	57-68
4. Agfacolor Bleach	5	68 ± 1
5. Wash	5	57-68
6. Agfacolor Fixer	5	64-68
7. Final Wash	10	57-68
8. Wetting Agent	1	64-68

* Increase development time 30% for films exposed principally by electronic flash illlumination.

† Or Intermediate Bath NZW for 4 min. at 68 F ± ½ F.

AGFACOLOR PAPER

Agfacolor Paper is an integral tripack designed to be exposed with white light using CC filters. The paper is available in different sizes (5″ × 7″, 8″ × 10″, 11″ × 14″, and 16″ × 20″) and something new—two contrasts, normal and hard (contrasty). The normal is for average negatives and the hard is for flat or soft negatives. The emulsions are coated on a medium-weight base—a thinner base than that used for Ektacolor 37 RC Paper. The surface is glossy and may be dried to a high-gloss or to a normal-gloss surface.

EXPOSING THE COLOR PAPER

Each package of Agfacolor Paper has color filter recommendations on the package. For your trial exposure, place these CC filters in the enlarger and expose from a test negative. The filter recommendation might look like this: 20—20. This means use a 20 cyan and a 20 yellow. 30—20 would mean a 30 magenta and a 20 yellow, etc.

Make a test print and process it, then judge it under standard conditions. (Refer to Chapter 4 for making tests and judging.)

PROCESSING AGFACOLOR PAPER

A new Agfacolor Paper process, Process 85, is proposed to be introduced in the fall of 1976. The steps involved, along with the temperatures and processing times, are as follows:

	Processing Time	Temperature (F)
1. Developer (82/85 CD)	1 min. 50 sec.	95 ± ½
2. Bleach-Fix (85/86BXR)	2 min. 45 sec.	95 ± 2
3. Wash	2 min. 45 sec.	80–95
4. Final Bath (85FI)	55 sec.	80–95
5. Spray Wash	5 sec.	80–95

TIPS FOR BETTER PROCESSING RESULTS

1. Agitate carefully; do not treat prints roughly. Remember you are handling wet paper.
2. Mix the chemicals carefully according to instructions.
3. Store Agfacolor Developer in a tightly stoppered brown glass bottle.
4. Store the paper under refrigerated conditions.
5. Judge Agfacolor prints the same way as Ektacolor prints. Add the same color filter as the color cast of the print.
6. Observe the filter rules in Chapter 4.
7. Variations from processing may be due to poor voltage supply. Check your power source, and if necessary, install a voltage regulator.

SOME PAPER PROCESSING FAULTS

1. *Light print:* underexposed or underdeveloped, developer solutions too cold.
2. *Dark print:* overexposed, overdeveloped, developer solutions too warm.
3. *Cyan fog:* bleach-fix in developer, also developer in bleach-fix bath. Use of color negative film developer in place of paper developer.
4. *Red fog:* iron contamination in water.
5. *Degraded-red fog or gray fog:* exhausted bleach-fix.
6. *Strong yellow fog:* paper stored in too warm a place.
7. *Red or yellow spots:* water on emulsion prior to development.
8. *Dark brown spots:* poor bleaching or insufficient agitation in bleach.

KODAK EKTACOLOR PRINT FILM, 4109

Kodak Ektacolor Print Film 4109 is available for making display transparencies from color negatives such as Kodacolor II, Vericolor II, and other Kodak color negatives.

Chemicals

Process C-22 is used along with Kodak Ektacolor Print Film Additive The additive is mixed with the developer replenisher and is used to maintain the activity of the developer at the proper level through replenishment. See the instructions that come with the C-22 processing kit. Ektacolor Print Film Stabilizer should be used along with the C-22 chemicals to improve stability of the yellow and magenta dyes.

Exposure

Expose as you would for Ektacolor 37 RC Paper. Use a Wratten 2B filter and a heat-absorbing glass in the optical system. A starting point would be to make test exposures of 10 and 20 seconds at 2 footcandles of illumination on the baseboard. The footcandle illumination is measured without any filters in the enlarger optical system. Use the filters that are recommended on the print film instruction sheet. Handle the print film in total darkness.

Processing (Agitation Technique)

Develop using hangers in 1-gallon or larger tanks. Use the manual agitation procedure as described.

Step 1. *Developer, Initial*—Lower the hangers into the solution and tap them sharply against the upper edges of the tank to dislodge any air bubbles that may be clinging to the emulsion. Then carry out the following agitation cycle *twice* during the first 15 seconds: In rapid succession (1) lift the hangers clear of the solution, (2) tilt them 60° or more in one direction (in the plane of the films), (3) reimmerse them, (4) lift the hangers clear again, (5) tilt them 60° or more in the opposite direction, and (6) reimmerse them. (If a hanger rack is not used, check the spacing of the hangers immediately after the final immersion.) Note that *two* tilts are required for *each* cycle, with no pause for draining. The entire cycle of six motions should be carried out rapidly but smoothly in about 7 seconds.

Step 2. *Developer, Subsequent*—Repeat the agitation cycle described above *once every 30 seconds.* Just before the end of the development time, drain the films for 10 seconds.

Step 3. *Other Solutions and Washes, Initial*—Agitate the films continuously for the first 15 seconds by lifting the hangers straight up out of the solution and reimmersing them four times. Only the initial agitation need be given during wash steps.

Step 4. *Other Solutions, Subsequent*—Once each minute, lift the hangers completely out of the solution and drain them for 5 seconds from one corner. Alternate the direction of tilting the hangers.

SUMMARY OF STEPS FOR KODAK COLOR FILM PROCESS C-22

For Kodak Ektacolor Print Film, 4109
(and for Kodak Ektacolor Slide Film, 5028)

Agitation: See instructions and follow them closely.
Timing: Include drain time (10 seconds) in time for each processing step.

Step or Procedure	Remarks	Temp	Manual Processing	
			Time in Min	Total Min at End of Step
1. Develop	Total darkness	75 ± ½ F (24 ± 0.3 C)	11	11
2. Stop Bath	Total darkness	73-77 F (23-25 C)	4	15
3. Harden	Total darkness	73-77 F (23-25 C)	4	19
Remaining steps can be done in normal room light				
4. Wash	Running water	73-77 F (23-25 C)	4	23
5. Bleach	See warning on label	73-77 F (23-25 C)	6	29
6. Wash	Running water	73-77 F (23-25 C)	4	33
7. Fix		73-77 F (23-25 C)	8	41
8. Wash	Running water	73-77 F (23-25 C)	8	49
9. Final Rinse	Kodak Photo-Flo Solution	73-77 F (23-25 C)	1	50
10. Dry	See instructions	Not above 110 F (43 C)		

MAKING 35MM SLIDES FROM COLOR NEGATIVES

Kodak Ektacolor Slide Film, 5028

You can make 1:1 contact transparencies, or you can project the color negative onto the slide film, thereby making enlarged or reduced images. Exposure is done through the use of a tungsten light source, such as an enlarger. The exposure time varies from ¼ sec. to 8 seconds. You must test your particular situation to find out the proper exposure time and color balance. Read the instruction sheet that comes with the particular roll of slide film you purchase and make an exposure ring-a-round. (See the color illustrations for an example of a ring-a-round.) Use the filtration suggested in the instructions.

Process the test film in C-22 solutions. Use the processing table on page 91 as for Ektacolor Print Film, 4109, except change the developing time to 17 minutes.

View the dry test and decide if you need to make any filtration changes. Your particular setup may require the use of some filters for your final exposures.

When dry, the transparencies can be cut apart and mounted in cardboard, plastic, or metal mounts.

7

PRINTS FROM TRANSPARENCIES

Most of us have many transparencies, 35mm or larger, which we often wished we had a print of for gift giving or just to show off to the family and friends. You can make these prints yourself, using one or both of two processes. The materials for these two processes are Ektachrome RC Paper or Cibachrome print material.

These materials are alike in that both are integral tripacks, but there the similarity ceases. Ektachrome RC Paper is on a resin-coated paper base, and Cibachrome is on a white opaque acetate base.

There are some important considerations to be looked at before you decide to use one of these reversal print processes. The easiest method of processing Ektachrome Paper is on a drum at 100 F. For this type of processing there are 1-gallon units of Kodak Ektaprint R-500 chemicals. Five different chemicals are required. For the Cibachrome print material, three different processing chemicals are required.

Very nice prints can be made from either of these processes, but you should not expect their quality to be the kind found in prints made from color negatives. You should select only good transparencies for printing. These should have neither excessively dark shadows nor predominant color casts. The picture should have been well lighted and exposed. Check to see that the highlights (the lighter tones) have detail in them and that they are not washed out.

Since you must go through more processing steps in these reversal processes, the total processing time is longer than for prints from color negatives using any one of the negative-positive processes.

KODAK EKTACHROME RC PAPER, TYPE 1993

This paper is an integral tripack with the construction as shown in the following diagram:

Sensitivity

Red→	CYAN DYE-FORMING LAYER
Green→	MAGENTA DYE-FORMING LAYER
Blue →	YELLOW DYE-FORMING LAYER
	RESIN-COATED PAPER BASE

The exposure is made directly from a transparency. The paper is relatively slow compared to its sister, Ektacolor 37 RC Paper. Your primary concern in exposure is to give the paper the proper amount of red, green, and blue light. These three quantities are controlled by the color-compensating filters used over the lens or in the optical system.

Ektachrome RC Paper is processed in trays or tanks in Kodak Ektaprint R-5 chemicals. It can also be processed in a Kodak Rapid Process or Model 11, 16-K, or 30A, using Ektaprint R-500 chemicals.

EXPOSING EKTACHROME RC PAPER, TYPE 1993

Storage of the Paper

Keep Ektachrome RC Paper in a refrigerator at 50 F or lower. You will be better off if you can store it in a freezer near 0 F.

As with any material stored in a cold place, Ektachrome RC Paper should be allowed to come to room temperature before it is used. This may require two to four hours unopened.

You should remove only the amount of paper you intend to expose. The remainder should be sealed back in its vapor-proof bag. Squeeze out any excess air before you seal it.

If it is necessary to store exposed paper, you must do it at 0 F or colder. The paper should be in air-tight container from which the air has been eliminated. The original vapor-proof bag would make a good storage container.

Special Exposing Equipment

It is necessary to use an ultraviolet absorbing filter such as a Wratten 2E and a Kodak infrared cutoff filter, No. 301.

Control of the Exposures

Since Ektachrome RC Paper is a tripack responding to red, green, and blue light, we must control this light through the use of CC or CP filters. You must think of the white light in the enlarger as red, green, and blue light combined. Since you are working with a reversal color material, you have to change your line of reasoning because it is different from working with a negative-positive process. If your test print has a red cast, then you can add the complementary color filter or cyan to the original filter pack. The procedure and reasoning can be found on page 96. Handle Ektachrome RC Paper only in total darkness.

Standardizing the Enlarger

Each emulsion of color paper lists a recommended change in filtration from a standard, but if you are working with the paper for the first time, your test will have to be made by trial and error. However, the following recommendations should be a help in your first attempt.

1. 2× magnification $f/5.6$.
2. 75-watt bulb.
3. 25M + 10Y CC filters (trial pack).
4. Heat-absorbing glass.
5. 2E Wratten filter + 301 filter.

(A change in one condition will result in large errors if you don't compensate. Example: Suppose you wanted to use 4× magnification instead of 2× at a given f/stop and time. This would result in increasing the time or opening up the lens to achieve the same result (normal print).

Using $f/5.6$, make a trial set of exposure times, like 10, 20, 30, 40 seconds. Make the area in each step large enough for easy judging, or make separate prints of each exposure time. These prints could be of a 4″ × 5″ or 5″ × 7″ size. Even better, you could make four 4″ × 5″ exposures on an 8″ × 10″ sheet. Important areas of the print should be included in these test exposures.

Process and dry the prints. Judge the prints, and make a second set if the originals were quite far off in color balance or density. If they weren't too far off, you might expose several transparencies using the new filter pack. Process and judge your results.

White Borders

You will normally have prints with black borders. You can make white borders if you make a special tool. It is simply a clean sheet of glass the same size as your color paper. Pasted to the center of the glass is a piece of black paper having a size slightly smaller than the image size on your print. The black paper must be fastened to the glass so that there are equal borders around it.

To use. Place the glass with black paper next to the emulsion of the exposed sheet of paper (naturally this operation must be done in the dark). Give an exposure of two times the print exposure without any negative in the optical system, but using the filtration previously used. Since this is a reversal paper, areas receiving large amounts of exposure turn out light (white).

Judging Reversal Prints and Making Corrections

It is important to view the prints under a standard source, such as those recommended in Chapters 1 and 4. You can estimate the filtration change needed in two ways.

1. View the print through CC filters. It is necessary to use the complementary color filter in order to correct the color cast. View the mid-tone areas in order to make a judgment. The following table will help you select the proper filters.

Color Cast on Print	*Viewing Filter to Use*
Red	Cyan
Green	Magenta
Blue	Yellow
Cyan	Red (Magenta + Yellow)
Magenta	Green (Cyan + Yellow)
Yellow	Blue (Cyan + Magenta)

It may be necessary to use more than one color of filter in order to make a proper judgment. If so, avoid using filters which together form neutral density. These would be:

1. Red and Green
2. Red and Blue
3. Green and Blue
4. Red and Cyan
5. Green and Magenta
6. Blue and Yellow

To make the change in your filter pack, use the following table to guide you.

Overall Color Balance	Viewing Filter	Correction to Original Pack		
		Subtract these filters	or	Add these filters
Cyan	Red	Cyan		Red (Magenta + Yellow)
Magenta	Green	Magenta		Green (Cyan + Yellow)
Yellow	Blue	Yellow		Blue (Cyan + Magenta)
Red	Cyan	Red (Magenta + Yellow)		Cyan
Green	Magenta	Green (Cyan + Yellow)		Magenta
Blue	Yellow	Blue (Cyan + Magenta)		Yellow

The method of correction depends on the filters you are using. For example: if you have cyan filters in the enlarger and the test is too cyan, the easiest correction to make is to remove some cyan filtration. You would not want to add red filters, for then you are adding neutral density and only increasing your exposure time. Besides, there will be too many filters in the optical system, resulting in poor image quality. See the example on page 99 for adding filters to the original pack.

If the test prints are quite far off in color, then it is impossible to get an accurate judgment by viewing with filters. The best you can do is to estimate the amount of correction needed.

2. For estimating the amount of color cast on the print, use the following table, adding the filters recommended to your original printing pack. When you make this addition, observe the rules of (1) no neutral density and (2) fewest number of filters possible.

Color Cast on Print	Amount of Color Cast and CC Filters to Use			
	Slight	Small	Moderate	Large
Red	025 Cyan	05 Cyan	10 Cyan	20 Cyan
Green	025 Magenta	05 Magenta	10 Magenta	20 Magenta
Blue	025 Yellow	05 Yellow	10 Yellow	20 Yellow
Cyan	025 Red	05 Red	10 Red	20 Red
Magenta	025 Cyan + 025 Yellow	05 Green	10 Green	20 Green
Yellow	025 Cyan + 025 Magenta	05 Blue	10 Blue	20 Blue

How does the addition of the above filters correct a color cast? Let us imagine a simple example. If a print has a cyan cast, the above table says to add a red filter. Why? The print is too cyan because there is not enough magenta and yellow dye to neutralize it. This resulted from the green- and blue-record layers not having enough exposed silver halides to form magenta and yellow dyes in the color developer.

We correct this by adding a red filter to the optical system. The red filter absorbs green and blue light, thus forming weaker silver images in the first developer than before in relation to the red record, thereby allowing more silver halides for color development. More magenta and yellow dye will be formed than before, neutralizing or reducing the cyan cast. The addition of the magenta and yellow dye will probably darken the print, so we must give an overall increase in exposure. All reversal color materials work in the same manner.

One way to calculate the change in the exposure times is to use filter factors. You have to compensate for the color of the dye added and also for the number of filter surfaces added or taken away.

To use the following data, first divide the old exposure time by the factor for any filter(s) removed from the pack. Then multiply the resulting time by the factor for any filter(s) added. When two or more filters are involved, multiply the individual factors together and use the product.

FACTORS FOR KODAK CC AND CP FILTERS

Filter	Factor	Filter	Factor	Filter	Factor
025C	1.1	025M	1.1	025Y	1.1
05C	1.1	05M	1.2	05Y	1.1
10C	1.2	10M	1.3	10Y	1.1
20C	1.3	20M	1.5	20Y	1.1
30C	1.4	30M	1.7	30Y	1.1
40C	1.5	40M	1.9	40Y	1.1
50C	1.6	50M	2.1	50Y	1.1
025R	1.1				
05R	1.2	05G	1.1	05B	1.1
10R	1.3	10G	1.2	10B	1.3
20R	1.5	20G	1.3	20B	1.6
30R	1.7	30G	1.4	30B	2.0
40R	1.9	40G	1.5	40B	2.4
50R	2.2	50G	1.7	50B	2.9

CORRECTING THE TEST PRINT

Example: Suppose your test print was made using the following filters:

$$20C + 20M$$

The test print had a bluish cast to it, so you viewed it with a 10Y filter. It seemed satisfactory, so you would add this filter to the original pack

$$\begin{array}{r} + 10Y \\ \hline \text{Total} = \quad 20C + 20M + 10Y \end{array}$$

You now have neutral density which you must remove

$$\begin{array}{r} -10 \quad -10 \quad -10 \\ \hline 10C + 10M \end{array}$$

You now use a 10C + 10M filter pack (plus heat-absorbing glass and No. 301 and 2E filters).

Exposure time correction: if the original time was 25 seconds using the 20C + 20M, then you multiply the filter factor for these filters together and divide into 25.

$$\begin{array}{c} (20C) \quad (20M) \\ 1.3 \times 1.5 = 1.95 \\ \text{Now} \quad 25 \div 1.95 = 12.8 \end{array}$$

Take the filter factors for the new filters and multiply them together.

$$\begin{array}{c} (10C) \quad (10M) \\ 1.2 \times 1.3 = 1.6 \text{ (approximately)} \end{array}$$

Multiply $12.8 \times 1.6 = 20\frac{1}{2}$ seconds

You would expose your second test using 10C + 10M at 20½ seconds.

PROCESSING EKTACHROME RC PAPER

Mixing Processing Chemicals Ektaprint R-5

Chemicals involved:
1. Kodak Ektaprint R-5 First Developer.
2. Kodak Ektaprint R-5 Stop Bath.
3. Kodak Ektaprint R-5 Color Developer.
4. Kodak Ektaprint R-5 Bleach-Fix.
5. Kodak Ektaprint R-5 Stabilizer.

The mixing instructions are included on each package, and they should be carefully followed. You should:

1. Use clean containers for mixing.
2. Use rubber gloves when mixing color chemicals.
3. Use the correct amount of water.
4. Use the correct temperature water.
5. Avoid stirring air into the developer solutions.
6. Make sure that each chemical (powder or liquid) is dissolved thoroughly before adding the next component.
7. Store in tightly stoppered bottles.
8. Store developers in small bottles so that when you use part of the kit, the remaining developer will be under proper storage conditions.
9. Pour chemicals (powder or liquids) slowly into the water while stirring. Avoid raising a dust.

Using Kodak Ektaprint R-5 Chemicals

Rinse out the trays and have the solutions in order. You will need a minimum of three trays. Arrange some kind of temperature-holding bath, either a large tray in which the developer trays will fit or a water jacket surrounding the developer trays. The latter could be an inch or two of water maintained by a standpipe in a sink.

The three trays are used (left to right) for first developer, stop bath, and running-water wash. Arrange everything in your sink. Pour the solutions, and check to see that they are at the proper temperature.

Each quart of solution is capable of developing six 8″ × 10″ prints, but you can probably process only three sheets conveniently in an 8″ × 10″ tray. Use enough solution so that the prints are covered adequately, and yet not so much that you will waste it. As you finish with each solution in a tray, dump the solution down the drain and rinse out the tray. Turn out all lights. Clip one corner of the lead print so you can identify it in the dark.

Step 1. *First Developer* (85 F ± ½ F)—4 minutes. Place the lead print in the developer, followed by another print every 20 seconds. Keep the emulsion sides face down. Every 20 seconds thereafter, pull the bottom sheet out, place it on top (without draining), and reimmerse it completely in the solution. Twenty seconds before the end of the development time, remove the first sheet and allow it to drain for 20 seconds; then immerse it in the stop bath. Transfer the other two sheets in the same manner at 20-second intervals. Repeat this procedure in each of the other processing steps.

Step 2. *Stop Bath* (83–87 F)—1 minute. Develop a technique of passing the prints from developer to stop bath without contaminating the developer. Agitate as previously, bottom to top. Complete a cycle of interleaving every 30 seconds. Drain the prints for the last 20 seconds of the stop-bath time. White lights may now be turned on.

Step 3. *Wash* (83–87 F)—4 minutes. Use running water at a rate of 3 gallons per minute.

If you have large amounts of air in the water, steps must be taken to remove it, or at least to change its character from small bubbles to large bubbles. Installation of an aspirator will help.

At this point following the first three steps, while the prints are washing, dump the first developer and stop bath. Rinse out the trays thoroughly. Place the color developer in one tray and the bleach-fix bath in the next. Check the temperature to see that the solutions are within tolerance.

Step 4. *Reversal Exposure.* Turn the prints emulsion side up in the wash tray, and starting with the lead print, expose the emulsion side at a distance of 1 foot from a No. 1 photoflood lamp for 15 seconds. Place the bottom print on top and expose it for 15 seconds. Continue the procedure until all prints have been re-exposed.

Fluorescent tubes may be used for re-exposure if the time of exposure is increased to 1 minute.

WARNING: Do not touch any metal or water when your hands are touching the lamp or its fixture—take precautions to avoid electrical shock. Also do NOT splash any water on the hot bulb or it may shatter.

Step 5. *Color Developer* (83–87 F)—4 minutes. Place the lead print in the color developer, followed by the remaining prints at 20-second intervals. Agitate in the color developer as previously. Drain the last 20 seconds of developing time.

While the prints are in this solution, dump the wash and refill the tray with clean water.

Step 6. *Wash* (83–87 F)—1 minute. Place the prints in the wash, making sure they don't stick together. Dump the color developer and rinse out the tray thoroughly. Place the bleach-fix solution in a clean tray. Drain the prints the last 20 seconds of the wash.

Step 7. *Bleach-Fix* (83–87 F)—3 minutes. Place the prints in the bleach-fix and agitate as previously described in Step 1. While the prints are bleaching, dump out the wash and refill the tray with clean water. Drain the last 20 seconds of processing time.

Step 8. *Wash* (83–87 F)—3 minutes. Place the prints in running water, making sure they don't stick together. Dump the bleach and rinse the tray out thoroughly. Place the stabilizer bath in the clean tray. Drain the prints for the last 20 seconds of the wash time.

Step 9. *Stabilizer* (83–87 F)—1 minute. Place the prints in the stabilizer and agitate as in Step 1. Dump the wash and refill the tray with clean water. Drain the prints the last 20 seconds of processing time.

Step 10. *Rinse* (83–87 F)—½ minute. Rinse and then drain the prints.

Step 11. *Dry* (not over 200 F). Air dry all prints.

TIMING

Start the timer immediately after the first step is started. Always allow a drain time of approximately 20 seconds to be sure the solution has drained from the paper before starting the next step (solution). Always figure this drain time as part of the timing of that particular solution and step of the cycle.

SUMMARY OF STEPS FOR 3½-GALLON SINK-LINE PROCESSING

Temperature of First Developer: 85 ± ½ F (29.5 ± 0.3 C)
Temperature of all other solutions: 85 ± 2 F (29.5 ± 1.1 C)
First two steps must be done in *total* darkness.
Remaining steps may be done in normal room light.

Solution or Procedure	Comments	Processing Time* (minutes)	Total Minutes at End of Step
First Developer	Temperature tolerance ± ½ F (0.3 C)	4	4
Stop Bath		1	5
Remaining steps may be done in normal room light			
First Wash	Running water at 3 to 4 gallons per minute	4	9
Reversal Exposure	Expose emulsion side for 15 seconds, 1 foot from No. 1 photoflood lamp		Reset Timer
Color Developer		4	4
Wash		1	5
Bleach-Fix		3	8
Final Wash	Running water at 3 to 4 gallons per minute	3	11
Stabilizer	See warning on label	1	12
Rinse	Agitate in running water	½	12½
Dry	Not above 200 F (93 C)		
	Total Process Time	21½	

*All times include a 15-second drain.

CLEANING OF EQUIPMENT

Baskets, reels, and film hangers must be washed thoroughly after each processing run to avoid contamination on the next run. Wash the equipment for 10 minutes at a high water-flow rate.

If the wash tanks used in the processing are also used for cleaning and washing the baskets, reels or other processing equipment, discard the water from the wash tanks and begin the cleaning operation with fresh water.

PROCESSING ON A DRUM

Using Ektaprint R-500 chemicals
1. Kodak Ektaprint R-500 First Developer
2. Kodak Ektaprint R-500 Stop Bath
3. Kodak Ektaprint R-500 Color Developer
4. Kodak Ektaprint R-500 Bleach-Fix
5. Kodak Ektaprint R-500 Stabilizer

Mix the chemicals according to the instructions on the packages.

Processing steps:

1. *Prewet the net blanket.* Use a tray large enough to hold the blanket with the ends of the bar resting on the edges of the tray. Fill the tray to overflowing with clean water at 70–102 F (21–39 C). Immerse the blanket with the bar away from you, and make sure the bar is turned as described in the processor manual.

2. *Start the drum revolving* by turning on the drive motor switch.

3. *Pour the Developer into the processor tray* with a careful, sweeping motion so that it is distributed evenly over the length of the tray.

4. *Turn out the room lights.* Total darkness is recommended until the paper is in the stop bath. Kodak Ektachrome RC Paper, Type 1993, can be handled under a suitable safelight lamp fitted with a Kodak Safelight Filter No. 10 (dark amber), or a Kodak Safelight Filter 0A (greenish yellow), and a 7½- or 15-watt bulb in the first wash and color developer steps. Handling under the safelight should be kept to a minimum to avoid blanket shadow patterns on some of the lower density areas of the print. It is suggested that safelights be located above the processor at least 4 feet away.

5. *Prewet the print in the water tray.* Immerse the print emulsion side down and agitate it continuously for 60 seconds (including a 10-second drain time). Then turn the print over and position it on the blanket assembly with the top edge of the print even with the lower edge of the bar. This will space the print approximately one bar width away from the blanket bar. This one bar width provides good front-edge wetting and uniformity.

6. *Hold the edge* of the print in contact with the blanket, lift the bar and print from the tray simultaneously. Drain for 10 seconds. *CAUTION:* Kinks, cracks, or breaks in the emulsion will affect development of the paper. *Handle the paper carefully.* The use of plastic gloves is recommended.

7. Proceed with the normal processing procedures as explained in your operator's manual and further explained here in the processing summary.

NOTE: If a print comes loose from the drum during processing, or if a processed print shows a magenta edging or other defect, be sure that you are following the recommended directions.

SUMMARY OF STEPS FOR PROCESSING ON THE KODAK RAPID COLOR PROCESSOR, MODEL 11 OR 16-K

Drum Temperature: First Developer Solution $100 \pm \frac{1}{2}$ F $(38 \pm 0.3$ C)
 Other Solutions 100 ± 1 F $(38 \pm 0.6$ C)
 Washes 100 ± 2 F $(38 \pm 1.1$ C)

Processing Step	Remarks	Model 11 Solution Volume Metric	Model 11 Solution Volume U.S. Liq.	Model 16-K Solution Volume Metric	Model 16-K Solution Volume U.S. Liq.	Time in Min*	Total Min at End of Step
1. Prewet	In tray of water—total darkness†					1	1
2. First Developer	Total darkness	200 ml	7 fl oz	325 ml	11 fl oz	1½	2½
3. Stop Bath	Total darkness	200 ml	7 fl oz	325 ml	11 fl oz	½	3
4. First Wash	Use safelight No. 10 or 0A	7.5–9.5 l/min	2–2½ gal/min	7.5–9.5 l/min	2–2½ gal/min	2	5
5. Color Developer	Use safelight No. 10 or 0A	200 ml	7 fl oz	325 ml	11 fl oz	3	8
Remaining steps can be done in normal room light							
6. Second Wash	—	7.5–9.5 l/min	2–2½ gal/min	7.5–9.5 l/min	2–2½ gal/min	½	8½
7. Bleach-Fix	—	200 ml	7 fl oz	325 ml	11 fl oz	1½	10
8. Final Wash	—	7.5–9.5 l/min	2–2½ gal/min	7.5–9.5 l/min	2–2½ gal/min	1½	11½
9. Stabilizer	—	200 ml	7 fl oz	325 ml	11 fl oz	1	12½
10. Rinse	—	—	—	—	—	¼	12¾
11. Dry	See instructions 120 to 150 F (49 to 66 C)	—	—	—	—	—	—

*The time for each step, except the prewet, includes a 5-second drain time. The drain time after the prewet should be 10 seconds. In each case, start draining in time to end the processing step and start the next one on schedule.

†Agitate frequently. Do not handle the dry print with wet fingers or the wet print with dry fingers.

Important: After each process, rinse blanket, drum, and tray with running water to remove all traces of processing chemicals. Wipe excess water from drum and tray before starting next process.

TIPS FOR BETTER PROCESSING

1. Turn prints around every so often so that during agitation you are drawing out the bottom print from a different edge.

2. Before you process for the first time, you might take some old black-and-white prints and practice interleaving and draining in a water-filled tray. Try it in complete darkness to get the feel of the process.

3. Be careful not to contaminate any solutions through carelessness.

CIBACHROME TYPE A COLOR PRINT SYSTEM

Cibachrome is a printing material for making color prints directly from color slides or large-size transparencies. This is a positive-to-positive process. Cibachrome is also an example of the silver dye-bleach process. The print material has three light-sensitive emulsion layers coated on a white opaque cellulose triacetate base. The dyes are azo dyes and are incorporated into the emulsion layers during manufacture. Below is a diagram of a cross section of Cibachrome color print material.

Blue-record layer Produces final yellow dye image
Yellow filter layer
Green-record layer Produces final magenta dye image
Red-record layer Produces final cyan dye image
White opaque triacetate base

Processing Chemistry

You should use the Cibachrome P-12 kit. This kit contains three chemicals that will process a total of twenty 8″ × 10″ sheets of Cibachrome color print material Type A. The size is ½-gallon.

Exposing

Use the filtration recommendation found on the Cibachrome package. First you must do an exposure ring-a-round. Start with a one footcandle intensity on the baseboard. This should be measured with the filters in the optical system, and in addition, a Wratten 2B filter (UV absorber) should be in the system. Make a series of exposure times on one sheet of paper. Try 5, 10 ,20, 40, and 80 seconds. Develop the sheet and view the results. Pick the step that most clearly represents the level of density you desire. If the color balance is not correct, make a filter ring-a-round using the table on page 97 as a guide. Use CC or CP filters as in Ektachrome printing. Begin with 50M and 50Y filters for a test print.

Make, say, four new exposures with different filtrations. If, for example, your first test was too magenta, you should make the filter test with reduced amounts of magenta filtration or additional cyan and yellow filtration. You should add a proportional amount of time if you add filters to the optical system. See the filter factor table on page 98. Process the filter test and view the results. The print may appear slightly different when dry. To see how much change you have, take a wet normal-appearing test and cut it in half. Dry one half and keep the other half in water. When the one half is dry, compare the two and see if there is any difference. Once you have arrived at the proper filtration, make a full-size print. This filtration should hold for the remainder of the sheets in the pack. Certain transparencies you print may require a slight filtration change not due to any change in the color paper, but due to the transparency itself, which may have a slight color cast you want to correct.

Processing with the P-12 Kit

Mix the chemicals according to the instructions in the kit.

Temperature: 75 F ± 3 F

STEP	TIME (in min.)
1. Developer	2
2. Bleach	4
3. Fix	3
4. Wash	3

A 15-second wash between Steps 1 and 2 and Steps 2 and 3 is recommended for people who are sensitive to the odor of the chemicals.

Drying

The prints must be hung up so that both the back and front may air dry. Do not run the prints through a print dryer.

Mounting

Prints may be mounted using double-coated, pressure-sensitive adhesive sheets or tape. Experiment with an old print before you try mounting your good print, because generally you cannot remove a print once you have positioned it.

Tips on Working with Cibachrome

1. Follow the manufacturer's instructions carefully when mixing the chemicals.
2. Use rubber gloves if developing in a tray.
3. Use a drum for developing, such as the Cibachrome drum.
4. If you intend to do a lot of Cibachromes, a mechanical agitator such as Besseler's is handy to have.
5. Ciba-Geigy manufactures a color retouching kit that may be used for small or large area color changes.
6. Selective bleaching formulas are also readily available from Ciba-Geigy.
7. Always follow the manufacturer's latest instructions, which are included in the processing kit or with the package of color paper.

8

VARIATIONS IN COLOR PRINTING

BLACK-AND-WHITE PRINTS FROM COLOR NEGATIVES

The color negative can be made to yield color prints or transparencies and even black-and-white prints. You can use any black-and-white paper, but ordinarily the blues will appear too light and the reds too dark. This is because most printing papers are only blue-sensitive.

A variable contrast paper, such as Kodak Polycontrast, will do a better job of reproducing the tones of the subject. The best prints should be made on a paper that is panchromatic (sensitive to all colors).

Kodak Panalure is specially made for use with masked color negatives, such as Kodacolor and Vericolor. Panalure has a pleasing, warm-black tone. It is available in one contrast grade only and in the following surfaces and paper weights:

1. White, glossy, smooth, single-weight (F).
2. White, fine-grained, lustre, double-weight (E).

Exposure of Panalure

Since Panalure is panchromatic, it is best handled in total darkness. However, the Wratten No. 10 safelight may be used if it is kept at least 4 feet away and is of low intensity (7½-watt bulb).

The paper can be used for enlargements or for contact prints. In enlarging, a suitable starting point is a 150-watt lamp, $f/11$, $2\times$ magnification, and 15 seconds for an average (normal) color negative. Expose a test print, process it, and judge it as you would a normal black-and-white print. If it's too dark, reduce the exposure time; if it's too light, increase the exposure time.

Processing Panalure

Develop in total darkness (this should be a snap after processing color paper in the dark) in D-72 (or Dektol), diluted 1:2, for 1½ minutes at 68 F. Agitate continuously. Rinse, fix, wash, and dry as you would any black-and-white print.

DODGING AND BURNING-IN

Often you will make a straight color print that could be improved by dodging and burning-in. This might be due to several reasons:
1. Subject contrast too great.
2. Lighting contrast too great.
3. Enlarger illumination uneven.
4. Negative too contrasty (overdeveloped).

In order to do dodging and burning-in, you need to use the white-light method of exposure, for the three emulsions must be treated equally and evenly.

Dodging

If an area is too dark, you can hold back some of the exposure, thereby lightening that area in the print. You will need some sort of tool, for you are interested in local areas, not in reducing the overall exposure. Your hands are very useful in dodging, for you can hold them in innumerable shapes. However, sometimes a small area in the center of the picture needs a special tool.

In this case, you can take a wire, coil the end, and fasten to the coil a small piece of paper *the shape of* the area to be dodged or held back, but *smaller* than the area.

When you are dodging, whatever tool you are using must be kept in motion during the exposure. If it is not, you will get a sharp outline of the dodging. Properly done dodging cannot be detected. Normally, dodging is done for only part of the total exposure time.

Burning-In

You might make a straight print where the sky, or maybe the illuminated side of a person's face, turns out to be too light. This is an instance where you would like to darken an area.

Again you can use your hands or fashion a tool out of cardboard. The most common burning-in tool is cardboard with a hole punched in it. The hole is made the shape of the area to be burned-in. Whatever tool you use, you must keep it in motion so that no outline is apparent on the print. You can also do dodging and burning-in using CC filters. These would be used in case you wanted to change the color of an area.

MULTIPLE PRINTING

For the person who wants to try one of the more difficult aspects of color printing, there is multiple printing. This is simply using two or more negatives to form a finished print. You might have a very beautiful scene except that the sky is bald—no clouds. So you either go out and shoot a cloud negative or use a negative that already has clouds in it. The cloud negative has to fit the character of the scene with respect to lighting, type of clouds, and so forth.

The object is to put the clouds in the scene. Proceed as follows:

1. Make a good print of the scene. Record magnification and CC filtration.

2. Make a good print of the second negative, blowing it up so that the character of the cloud fits the first picture. Record the magnification and the CC filtration.

3. Make a mask of the scene from black paper. This is done by drawing the horizon line on the paper and cutting the paper into two parts, sky and non-sky.

4. Make an exposure of the sky onto a sheet of color paper using the non-sky mask to prevent any exposure of the foreground. Hold the mask up off the paper so that a fuzzy edge is formed. Keep the card in slight motion.

5. Now cover up the exposed paper or remove it in such a way that you replace it in a given place; put the scene negative in the enlarger. Use the sky mask (holding it up off the paper) and make an exposure of the scene.

6. The hardest part is trying to minimize the division line between the two negatives where the horizon meets. You will have to experiment as to where the masks will do the best job.

7. Remember when you change negatives to set the proper filtration into the enlarger. Line up the images and masks. A sheet of white paper with a horizon line on it will help line up the negatives.

8. If you obtain a reasonably good print, but still show a faint division line, use retouching to spot-in the defects.

RETOUCHING

Color Negatives. Defects in color negatives may be removed by retouching. Some of the most common defects are blemishes in a portrait. To retouch them, you use the following colored pencils:

Mongol Number 860—Red and Blue
Colorama Number 8056—Crimson
Colorama Number 8045—Victoria Blue

First, apply a few drops of retouching medium on the emulsion of the negative, spread it out with a small wad of cotton, and then rub dry with a larger wad of cotton. Keep the cotton moving until the medium (fluid) is even and dry.

Second, sharpen the pencils to a fine, sharp point.

Third, retouch using a stippling motion. Very lightly touch the lead to the negative. When retouching color negatives, remember the defects appear in complementary colors. The colored pencils are used as follows:

1. Red—for reddish blemishes, showing up as green spots on the negative.
2. Blue—for prominent veins, showing up as yellow lines on the negative.
3. Black lead—for dark spots, showing up as light spots on the negative.

Work with the pencils until the spot blends in with the background or surrounding area. Be careful you don't over-retouch. If you put too much colored pencil on, then the retouched areas will print in their complements. Example: you will get green spots where you worked with the scarlet pencil. To remove pencil work, apply more retouching fluid.

Dark spots on negatives cannot be removed easily. Etching is not practical on color negatives because of the three emulsion layers. If you have dark spots on your negatives, let them print and spot them out on the finished print.

Color Prints

Prints also may be retouched. Probably the most common form of retouching on prints is spotting. It is practically impossible to make a print without any dust spots. Therefore, you will often need to spot-in these light-colored spots on the print.

Flexichrome dyes are very useful for working on color prints. You need only four to start with—cyan, magenta, yellow, and neutral. From these four you can mix any color you desire.

To apply the color on a print, take a sable brush, No. 1 for small areas or No. 3 for larger areas, and moisten it in water. Rub the brush on one of the dye pats and then transfer the color to a small cup in which you have a few drops of water. Transfer the dye from the various pats of Flexichrome dye and mix the combination in the water. When you have formed the color you desire for spotting, dip your brush into the color and wipe most of it off on a clean blotter. As you wipe, twist the brush and pull it backward, drawing the hair to a fine point. The trick is to get a "dry" brush, yet one that is moist enough to leave some color on the print. Stipple in the area, adding color until the light spot is filled in and disappears. Practice is needed unless you are quite experienced at retouching. Work on some old prints before you attempt spotting on a good print.

If you are working on Ektacolor or Ektachrome prints, the "dry" brush is a must, for if you get the emulsion wet, you will get a bluish-cyan color. This cast disappears on drying, but it hinders you when you are spotting, since you can't tell how much color to apply.

INTERNEGATIVES

Kodak Internegative Film 6110 is a sheet film specifically designed for making color negatives from transparencies, color prints, or artwork. A 35mm

transparency can be enlarged to a 4″ × 5″ color internegative, and this negative is capable of producing prints larger than 16″ × 20″. The quality of these prints, while excellent, is not as sharply defined as the quality of an enlargement from an original color negative. This is because the internegative system requires printing through two film bases, and two optical systems are used. Comparison of color balance, original to duplicate print, is excellent.

Internegative film is unique in its performance. A correctly exposed and processed internegative will do a good job of recording the contrast, detail in shadows, and highlights of the original, as well as reproducing the original colors. Overexposure of the internegative will result in a sharp increase in contrast. The success of the internegative is dependent upon the careful measurement of the intensity of the enlarger light source, the making of a test exposure of a step wedge or three-point transparency guide (Kodak Q6C), and the measurement of the test exposure. The test exposure measurement indicates any corrective changes required in the initial filtration (color balance) and also indicates any change required in exposure time.

Basically, two neutral steps (A and B) of the three-point guide represent the extremes of density of all transparencies. When read on a densitometer through status M filters, these two steps may or may not show a variance from a normal reading or "aim point." A variance of color indicates the need for filter correction. Neutral density (red reading) is the amount of measured density correction (exposure) needed.

Characteristics of Internegative Film

There are 11 layers on an acetate base consisting of: 2 blue-sensitive yellow dye-producing layers, 2 green-sensitive magenta dye-producing layers, a gelatin interlayer, 3 red-sensitive cyan dye-producing layers, a gelatin overcoating, an antihalation coating, and a yellow filter layer. The coating order is normal; that is, blue, green, and red layers. The yellow filter layer is between the blue and green layers and prevents blue light from reaching the green- and red-sensitive layers, which are also partially sensitive to blue light.

There are dye couplers and silver halides in each of the light-sensitive layers. These layers are processed through development to the correct dye color: from top to bottom—yellow, magenta, and cyan dye, respectively.

The dye coupling takes place in the C-22 process. A special color developer replaces the standard developer. The remainder of the process is standard.

Exposing Using the Three-Point Transparency Guide

1. Place the original transparency in the enlarger, emulsion side up. Project the image to 4″ × 5″ on the easel.
2. Remove the transparency.
3. Insert the filtration into the enlarger head: 20M+ 50Y.

4. Place the probe of a footcandle meter in the center of the illuminated area on the easel.

5. Turn out the room lights.

6. Adjust the enlarger light intensity by turning the lens diaphragm until the needle on the footcandle meter dial reads 0.5 footcandle.

7. Make two test exposures on 4″ × 5″ Internegative Film 6110, one at 9½ seconds and one at 8½ seconds. To do this, place the film accurately on the printing easel, emulsion side up. Place a masked three-point transparency guide (Q6C) directly over (in contact with) the unexposed film. Make the 9½-second exposure. Turn the masked three-point guide end for end and make the 8½-second exposure.

Mask the guide as below:

8. Record all data: film emulsion number, filtration, footcandle reading, and date.

9. Process the test film as per the C-22 modified instructions.

Processing

Kodak Internegative Film 6110 must be processed in modified C-22 chemistry. The developer used for internegative processing is a working solution made up of Kodak Internegative Starting Solution and Kodak Internegative Replenisher. See the mixing instructions packed with each of the solutions and in the C-22 kit.

Agitation is critical. Film in hangers hould be tilt-drain agitated continuously for 15 seconds (four lifts in 15 seconds). Subsequent agitation: tilt and lift (right tilt and left tilt) every 15 seconds. Allow 10 seconds drain time. For the remaining processing steps see the following processing chart. If you have your exposed internegatives processed commercially, be sure that you mark clearly on the film package EXPOSED INTERNEGATIVE FILM.

SUMMARY OF STEPS FOR PROCESSING KODAK EKTACOLOR
INTERNEGATIVE FILM 6110

Agitation: See instructions.
Timing: Include drain time (10 seconds) in time for each processing step.

Solution or Procedure	Remarks	Temp F	Temp C	Time in Min	Total Min at End of Step
1. Developer	Agitate as prescribed	75± ½	24± 0.3	5	5
2. Stop Bath		73-77	23-25	4	9
3. Hardener		73-77	23-25	4	13
Remaining steps can be done in normal room light					
4. Wash	Running water	73-77	23-25	4	17
5. Bleach	See warning on label	73-77	23-25	6	23
6. Wash	Running water	73-77	23-25	4	27
7. Fixer		73-77	23-25	8	35
8. Wash	Running water	73-77	23-25	8	43
9. Final Rinse	Kodak Photo-Flo Solution	73-77	23-25	1	44
10. Dry	Remove film from hangers	Not over 110	Not over 43		

CALIBRATING THE INTERNEGATIVE TEST EXPOSURE

Measure the densities of the neutral patches A and B of the processed test exposure made from the three-point guide. Use the 9½-second test. These high and low densities are read successively through the red, green, and blue filters of a color densitometer.

Subtract the densities (red, green, and blue) of the B patch from the A patch. Record the differences. The *minimum* density reading through the red filter should be 0.15–0.20. The test areas we have read represent the extremes

of all transparencies. We can assume an ideal density difference (aim point) of red 0.90, green 0.90, and blue 0.90 (±0.02). If the density differences of the test are not within the tolerances, another test should be made incorporating filter changes and an exposure adjustment.

Test example:
Trial exposure: 9½ seconds using 20M + 50Y filtration.
Areas A and B read on the densitometer:

	Red reading	Green reading	Blue reading
Maximum density (A)	0.98	1.32	1.64
Minimum density (B)	− 0.14*	− 0.48	− 0.88
Density difference	0.84	0.84	0.76

* The reading of 0.14 indicates a slight underexposure. This reading should be between 0.15 and 0.20. If the 9½-second red reading is greater than .20, read the 8½-second readings and use them for the calculations. If the 9½-second red reading is very low, make a new set of tests using longer exposure times.

Filtration calculation:

	Red (cyan) reading	Green (magenta) reading	Blue (yellow) reading
1. Record density differences	0.84	0.84	0.76
2. Record test filtration	0.00(C)	0.20(M)	0.50(Y)
3. Add 1 and 2	0.84	1.04	1.26
4. Record aim point	0.90	0.90	0.90
5. Subtract step 4 from step 3	−0.06	+0.14	+0.36
6. Add or subtract neutral density equal to smallest value so that one value zeros out	+0.06 0.00	+0.06 0.20	+0.06 0.42
7. Filtration for new test:		20M +	42Y

Exposure calculation: Using the table in the following section, find the factor for the neutral density used in step 6 (+0.06). RULE: You add or subtract the neutral density numbers, but you multiply or divide their factors.

neutral density	factor
0.05	1.12
+0.01	×1.02
0.06	1.1424 (round off to 1.14)

RULE: Multiply the original exposure time by this factor if the neutral density in step 6 is (+); divide the original exposure time by this factor if the neutral density in step 6 is (−). Example:

9½ seconds × factor of +1.14 = 10.8, or 11 seconds.

Make the new test at 11 seconds using 20M + 42Y filtration.

Check the new test. If it is within tolerance, proceed with internegative exposures from any transparency, using the same film emulsion and identical conditions as for the test. Suggestion: Use a film holder for holding the film flat for the final exposure.

The internegative can be printed as you would any other color negative. However, you will probably find that the color printing balance is different than for normal Vericolor negatives.

EVALUATING COLOR NEGATIVES

A color densitometer may be used to help tell you how to print a new negative. In order to use a densitometer, the new negative must have areas in it similar to areas in your standard negative. These could be flesh tones, for example.

Read both the standard negative and the new unprinted negative on the densitometer using the red, green, and blue filters. You will get three different density readings. The readings are used in the following way.

Make three columns; label them cyan-red, magenta-green, and yellow-blue. Place the red readings in the cyan column, the green readings in the magenta column, and the blue readings in the yellow column.

	Red (cyan)	Green (magenta)	Blue (yellow)	
Example 1.				
Readings of standard negative	0.90	1.25	1.70	(1)
Add to the densities in (1) the filter pack used to print the standard negative.	00	+ 50M	+ 50Y	(2)
Total of (1) plus (2)	.90	1.75	2.20	(3)
New negative densities (4)	1.10	1.60	2.00	(4)
Subtract reading of new negative (3) minus (4):	− .20	.15	.20	(5)
Remove any minus numbers by adding neutral density (6)	+ .20	+ .20	+ .20	(6)
	00C	35M	40Y	(7)

Filter pack for new negative would be 35M + 40Y.

Exposure time must be increased because you had to add neutral density (6). The following table will give you the factor.

If old exposure time was 10 seconds, then the new time is

$$10 \times 1.58 = 15.8, \text{ or } 16 \text{ seconds.}$$

Neutral Density	Factor	Neutral Density	Factor	Neutral Density	Factor
.01	1.02	.25	1.78	.60	3.98
.02	1.05	.30	1.99	.65	4.46
.03	1.07	.35	2.24	.70	5.00
.04	1.10	.40	2.51	.75	5.62
.05	1.12	.45	2.82	.80	6.31
.10	1.26	.50	3.16	.85	7.08
.15	1.41	.55	3.55	.90	7.94
.20	1.58				

Example: .42 ND = .40 + .02 convert to factors $2.51 \times 1.05 = 2.64$ (factor for .42 ND).

If you had to subtract neutral density at step (6) then you would divide your original time by the factor.

	Red (cyan)	Green (magenta)	Blue (yellow)	
Example 2.				
Standard negative readings	.90	1.25	1.70	(1)
Filter pack	00C	+ 50M	+ 50Y	(2)
Sum:	.90	1.75	2.20	(3)
Subtract new negative densities—	.85	1.30	1.90	(4)
(3) minus (4)	.05	.45	.30	(5)
Subtract smallest neutral density	− .05	− .05	− .05	(6)
(5) minus (6)	00C	40M	25Y	(7)

New filter pack would be 40M + 25Y. If original time was 10 seconds, the new time would be $10 \div 1.12 = 8.9$, or 9 seconds.

9

GLOSSARY

Absorption. The retention by a body of a substance or energy (such as light). Example: black paint absorbs all wavelengths of light.

Additive Color. A color process in which colors are synthesized (put together) by the addition of colored lights of the three primary colors, red, green, and blue.

Agitation. A method for ensuring even development of film or paper. May be done by stirring up the solution, moving the hangers or reels during development, or interleaving the film or paper.

Analysis. The first stage in any three-color process where the amount of red, green, and blue light present in the subject can be recorded by three emulsions (tripack) individually sensitive to red, green, or blue light. It may also be done through the use of three separation negatives, one exposed through a red filter, one through a green filter, and one through a blue filter.

Base. The support material for color film and paper on which the light-sensitive emulsions are coated. In film it may be cellulose acetate or one of the new extruded plastics.

Brightness. That dimension of color which describes the sensation as ranging from very dark to very light. Example: a pink is very bright, and a maroon is quite dark.

Burning-In. That technique where extra exposure is added to some part of the image for improving the visual appearance of the final picture.

CC Filter. Color-compensating filters used over the lens or in the optical system to control the amount of red, green, and/or blue light reaching the color material being exposed.

119

Clear Flash. Bulbs that emit a continuous spectrum of high intensity and short duration of about 3800 to 4000 Kelvin.

Color. A visual sensation that can be described in terms of hue, saturation, and brightness.

Color Balance. The relationship between the densities of the three dye images in a color print or transparency. If one dye is overly prominent, the print has a color balance of that hue.

Color Couplers. The color formers in some color negative films that have an original color or hue in the film during exposure and that change during color development to some other hue.

Color Negative. A representation of the original subject in terms of three superimposed color dye images—cyan, magenta, and yellow. Highlights have a heavy density, and shadows have a thin density. Subject appears in complementary colors.

Color Temperature. A numerical rating in Kelvin units (K) given to a light source when it visually matches a heated black body at a high temperature.

Complementary. A color is complementary to another color when a mixture of the two, additively, will produce a white.

Contact Proofing. A method of exposing, under standard conditions, color negatives placed directly on a piece of color paper and producing 1:1 reproductions. The purpose is to determine their color balance or composition.

Contamination. The introduction of chemicals or impurities into any of the processing solutions, thereby changing the chemical composition, even slightly.

CP Filters. Color-printing filters used in an optical system to control the amount of red, green, and blue light reaching the color material being exposed. Images must not be projected through a CP filter.

Cyan. A blue-green color; one of the subtractive primaries.

Daylight. A light mixture of skylight and sunlight having a color temperature of about 6500 K.

Definition. The fineness of detail in a negative or positive print.

Density. The comparative amount of light absorbed by the dyes (or silver) in the image. It is expressed as the logarithm of the ratio of the incident light (light falling on image) to the transmitted light (light passing through image).

Diffuse Illumination. Light rays being transmitted through a material or being reflected off a material in all directions. This illumination tends to spread the light evenly and softens the sharpness of shadows.

Dodging. Holding back a portion of the picture during exposure with your hands or specially designed tools.

Electronic Flash. A light source that utilizes the short duration flash of light produced by discharging a medium or high voltage charge through a gas-filled tube. Can have a color temperature of 4800 to 6000 K.

Emulsion. The light-sensitive coating or coatings on a film or paper base, consisting of silver salts and other chemicals suspended in a medium (gelatin).

Enlargement. A print, negative, or transparency made from a smaller original through a projection process.

Exhaustion Point. The inactive state reached by a solution when its active materials are used up.

Exposure. The combination of intensity of the light (coming through the negative) times the time in seconds. The exposure would be the same were the intensity doubled for the second case and time cut in half. $E = i \times t$ (i = intensity; t = time).

Exposure Latitude. The area from the point of underexposure to the area of overexposure that still produces an acceptable result. For reversal film this area is small, in the vicinity of 1 stop or less. For negative color films the latitude is considerably greater, mostly on the overexposure side.

Ferrotyping. The process of putting a high gloss on a print by drying a print that has been squeegeed onto a highly polished surface.

Filter Pack. A set of filters in the optical system of an enlarger, which is used in making a color print.

Fluorescent Lamp. A vapor discharge lamp consisting of a glass tube coated with a substance (phosphor) that gives off light. The phosphor absorbs short wavelength energy and emits longer wavelength energy.

Footcandle. A unit of illumination representing the light intensity over a surface one foot away from a standard candle.

Heat-absorbing Glass. A filter (glass) that allows light rays to pass through it, but holds back heat rays.

Highlight. The part of the picture that is brightest, being reproduced as a heavy density in a negative and the lightest density in a transparency or print.

Hue. That aspect of color that is referred to as either red, yellow, green, cyan, blue, or magenta, etc.

Humidity. A measurement of the amount of moisture in the air. Complete saturation is 100 per cent humidity.

Integral Tripack. Three emulsions coated on a single side of a photographic base (film or paper).

Interlayer. A separating layer between emulsions on a color film or paper.

Internegative. A color negative made from a transparency specifically for the purpose of printing.

Kelvin. A temperature scale starting at absolute zero (−273 C), abbreviated K. It is used in photography as an abstract scale to represent color temperature.

Latent Image. The invisible image in an emulsion, which is capable of being made visible by a developer.

Lead Print. The first of a group of prints being developed, first in the developer and first out.

Logarithm. The "power" to which the "base" number (usually 10) has to be raised to equal a given number.

Magenta. A purplish-red color, which is not found in the spectrum. Its complement is a green. One of the subtractive primary colors.

Magnification. The ratio of the image and object sizes. If the image is twice as long as the object, the magnification is 2×.

Mask. A positive or negative image used in register with a negative or a transparency.

Masking. The process of changing the reproduction characteristics of the original image by adding a mask to the original negative or transparency.

Mid-tone. A tone comparable to a gray. A tone half-way between a white and a black.

Monochromatic. Light of a single wavelength, for example, a sodium vapor light (yellow-orange).

Monopack. Three light-sensitive emulsions coated on one photographic support (film or paper).

Neutral Density. A gray, which is made up of equal parts of cyan, magenta, and yellow dye. Also a filter that equally absorbs all wavelengths of the spectrum.

Newton's Rings. Concentric bands of colored light resulting from the interference of light when two transparent surfaces are not quite in contact.

Opalescent. Having a milky appearance.

Opaque. Not transparent; impervious to rays of light. Also a material used to block out light.

Photoflood Lamp. A highly efficient tungsten lamp of approximately 3400 K.

Photographic Effect. The result (negative or print) actually obtained in a photographic situation. The photographic effect obtained from two lamps of the

same color temperature may be quite different due to the different energy emissions of the lamps.

Photometer. An instrument for measuring or comparing illumination.

Positive. An image in which the tones correspond to those of the original.

Primary Colors (see additive colors). Red, green, and blue.

Processing. The chemical treatment of exposed film or paper to form a permanent visible image.

Reciprocity Effect (law). If the illumination of a subject is decreased or increased and a proportionate increase or decrease in exposure time is given, a negative of the same density will result. Most photographic materials fail to follow this law. Generally a greater than proportionate increase in time or intensity is necessary to maintain the same density.

Reduction. Making a print or negative smaller than the original.

Reversal Color Film. A film that will produce a positive reproduction of the subject, a transparency.

Reversal Exposure. The white-light exposure given after first development prior to color development for a reversal color material.

Saturation. That dimension of color that specifies the intenseness of the color. A fire-engine red is a highly saturated color. A pink is a color having low saturation. Dark colors have low saturation.

Separation Negatives. Three negatives exposed separately to red, green, and blue light (generally through color filters). Can also be produced by using negative materials sensitive to only one color.

Shadow. The darker parts of a transparency or the lighter parts of a negative.

Spectrum (spectral). A colored band produced when white light is passed through a prism. It contains all the colors of which white light is composed. Example: the rainbow.

Specular. Referring to reflection where light is directed without scattering or diffusion.

Specular Illumination. Light coming from a source in parallel rays. Produces harsh, sharp shadows. Example: condenser enlarger.

Standard Negative. A color negative containing known reference areas and capable of producing a good color print.

Stray Light. Non-image-forming light, a fogging light.

Subbing. The material coated between the emulsions and film base, allowing the emulsion to adhere to the base.

Subtractive Primaries. Cyan, magenta, and yellow colorants.

Synthesis. The process of putting a colored subject together using either colored light (red, green, and blue) or colored images (cyan, magenta, and yellow).

Test Strip. A series of widely varying exposures on a piece of paper for the purpose of determining the correct exposure.

Transmission. Passage of light through a transparent or translucent medium, never 100 per cent.

Transparency. A positive image on a transparent support.

Tricolor Printing. A method of exposure using separate exposures through red, green, and blue filters.

Tungsten. An incandescent lamp giving off light in all parts of the spectrum, but more red light than green, or blue. Ranges from approximately 2600 to approximately 3400 K.

Ultraviolet Absorber. A filter that transmits the visible rays and absorbs the ultraviolet (short wavelength) radiation.

Voltage Adjuster. An apparatus for manually adjusting the voltage output in any given system, a Variac. A voltmeter must be used in connection with the Variac so that the output may be determined.

Voltage Regulator. A variable transformer designed to deliver a constant output, despite changes in input voltage.

White-Light Printing. Exposure of color materials using a tungsten lamp and CC or CP filters for control of the color quality.

INDEX